MW01025472

Cats *in* *the* Navy

Cats *in the* Navy

SCOT CHRISTENSON

NAVAL INSTITUTE PRESS

ANNAPOLIS, MARYLAND

Naval Institute Press
291 Wood Road
Annapolis, MD 21402

Library of Congress Cataloging-in-Publication Data
Names: Christenson, Scot, 1968- author.
Title: Cats in the navy / Scot Christenson.
Description: Annapolis : Naval Institute Press, [2022] | Includes
 bibliographical references.
Identifiers: LCCN 2021062236 | ISBN 9781682478387 (hardcover)
Subjects: LCSH: Cats—Anecdotes. | Navies. | Ships. | Human-
 animal relationships. | BISAC: PETS / Cats / General |
 HISTORY / Military / Naval
Classification: LCC SF445.5 .C57 2022 | DDC 636.8—dc23/
 eng/20220118
LC record available at https://lccn.loc.gov/2021062236

♾ Print editions meet the requirements of ANSI/NISO z39.48-1992
(Permanence of Paper).
Printed in the United States of America.

30 29 28 27 26 25 24 23 22 9 8 7 6 5 4 3 2 1
First printing

For Carroll

To paraphrase T. S. Eliot . . .

A cat needs a ship that's particular,

A ship that's peculiar, and more dignified.

Else how can he keep up his tail perpendicular,

Or spread out his whiskers, or cherish his pride?

May this book find its perfect (purr-fect) home in Cat Haven

Contents

Acknowledgments

I owe a round of heartfelt thanks to many people who helped make this book finally happen.

First to my parents, who encouraged me to write more books. They probably did not expect one about cats, but here it is.

To Vice Adm. Peter Daly, USN (Ret.), for allowing the Naval Institute Press to publish the book even though he is allergic to cats.

To Jaci Day, Liese Doherty, and Karen Eskew for always being so willing to help me with the tasks that I am too dense to do myself.

To Rhonda McIntyre, who would have loved this book.

To Tom Grant, Carlton Real, and Ian Bugge for all the pints of spingo at the Blue Anchor. Kernow bys vyken!

To the Orange Park gang for the unforgettable days with the grinch. Those stories would make a great book—but no one would ever believe them.

To Anne Baker: "Double dang," you lose the bet!

To Lisa Padden, for being one of the few constants in my life.

To "PAF" Grant, a gentleman and great storyteller who served as a mentor during an important time.

To Caitlin Smith, for not hesitating to keep me in check when I needed it.

To Laural Hobbes, the "president for life" of the Gaithersburg Cat Fan Club.

Ольга Бородич за то, что она красивая и умная партнерша по танцам.

Моим русским друзьям, которые научили меня водке и салату Оливье.

ขอบคุณกุ้งมากๆที่เป็นส่วนหนึ่งในการผจญภัยของผม

PART I

A History of Cats at Sea

~~~~~~~~~~~~~~~~~~~~~~~~~~~~~~~~~~~~~~~~

*S*ailors and cats have a special relationship dating back thousands of years. Ancient Egyptian seafarers brought cats on voyages for companionship and to protect cargo from vermin. When food supplies for the crew ran low, the Egyptians used cats to catch birds in the reeds along the Nile. Over the centuries, cats would continue to prove their value by keeping ships from being overrun with mice and rats that would otherwise eat into provisions, chew through ropes, and spread disease.

~~~~~~~~~~~~~~~~~~~~~~~~~~~~~~~~~~~~~~~~

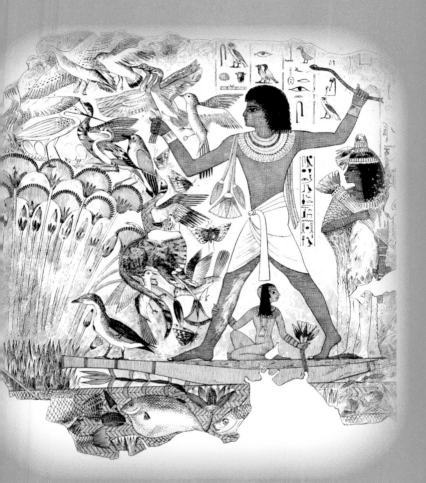

A tomb painting for the ancient Egyptian court official Nebamun depicts him fishing and fowling from a boat while his cat catches birds in the reeds, circa 1350 BC. When their cats died, Egyptians shaved off their own eyebrows as a sign of mourning.

(Library of Congress)

~~~~~~~~~~~~~~~~~~~~~~~~~~~~~~~~~~~~~~~

*D*uring the Age of Sail, rodents presented another danger because they would skitter through magazines and track gunpowder throughout the ship. Eventually, the trail could become a de facto fuse leading back to the magazine, which might then be accidentally lit by lamps or the fires in the galley. As navies modernized, rats posed further problems by getting stuck in machinery and disabling equipment, thus putting ships at risk during combat.

~~~~~~~~~~~~~~~~~~~~~~~~~~~~~~~~~~~~~~~

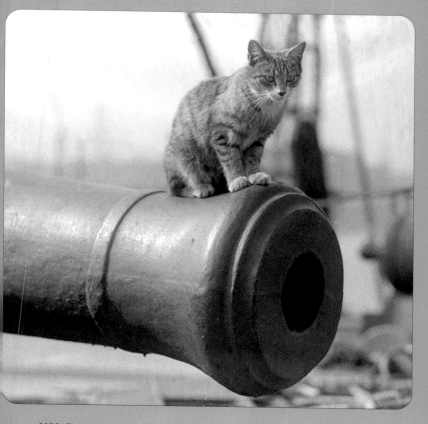

USS *Constitution* mascot Peggy, circa 1930. Launched in 1797, the *Constitution* is the world's oldest commissioned naval vessel still afloat.

(Courtesy of the Boston Public Library, Leslie Jones Collection)

*B*eginning in the eighteenth century, the U.S. government purchased large numbers of cats to be housed near stored materials that were susceptible to rodent infestation. Because vast storerooms of paper were havens for nesting mice and rats, cats were needed to patrol these areas and keep vital documents from being damaged or destroyed. Many such cats were provided to both the Army and the Navy.

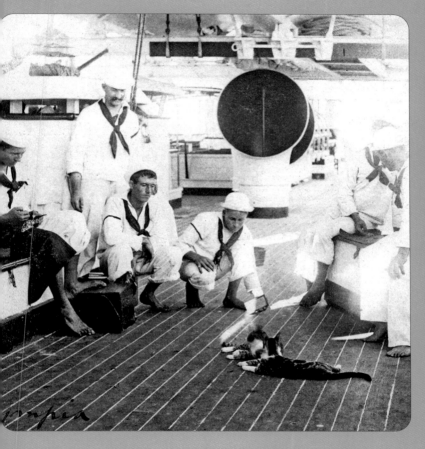

Sailors on board the USS *Olympia* use a mirror to play with the ship's cats, 1898. Thanks to advances in cat toy technology, mirrors have been replaced by laser pointers.

(Naval History and Heritage Command)

There were typically two types of cats on ships: permanents and vagrants. A permanent cat was usually brought on board by a sailor and considered a member of the ship's company. Unofficial enlistment papers were often drawn up, giving the cat a rating of either mascot or rat catcher. In contrast, a vagrant cat crept onto a ship in port and made itself at home. Like most cats, vagrants displayed a proprietary air, viewing the ship as their own and the crew as the actual stowaways. Yet sailors did not mind these little interlopers and considered it a good sign when a stray cat chose their ship. Vagrant cats performed most of the duties of the permanent cat but freely changed ships in port when better meals and lodgings could be found with a different crew. Essentially, the permanents served as active-duty crew and the vagrants as contractors.

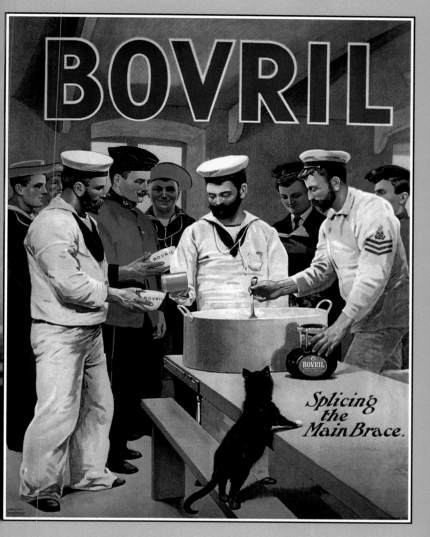

A Royal Navy ship's cat eagerly waits with the crew for a ration of Bovril beef tea in this advertisement, circa 1916. In the 1942 film *In Which We Serve*, British sailors are shown drinking Bovril that had been heavily laced with sherry to keep them warm.

(Author's collection)

*P*ermanent cats that wandered ashore and failed to return before the ship got under way were considered to be on unauthorized leave. If caught by the shore patrol, fugitive cats were usually returned to their ship and sometimes faced a mock captain's mast, with the commanding officer hearing the case and imposing punishment. For misconduct, a cat might be sentenced to a term in the brig with reduced rations, or have its liberty restricted at the next port.

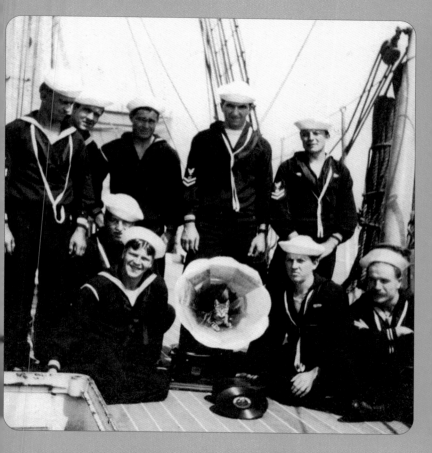

His captain's voice? Reminiscent of the classic RCA logo, the USS *McCulloch*'s cat sits in the horn of the crew's phonograph, 1909. Recent research has found that cats enjoy music if it is composed using pitches, tones, and tempos that mimic purring and chirping birds.

(Author's collection)

~~~~~~~~~~~~~~~~~~~~~~~~~~~~~~~~~~~~~~~~

*V*agrant cats were known to disappear in a foreign port, often hitching a ride on a different ship, only to greet their surprised crew on another dock thousands of miles away—perhaps having decided that the original ship was better after all. In 1939 a ship's crew was puzzled when they were met by their cat in Buenos Aires, despite the mascot having gone missing just hours before they left Liverpool. After checking with other sailors in the local bars, they learned the cat had been waiting there for a week, having wandered onto a much faster ship that had sailed from Liverpool on the same day.

~~~~~~~~~~~~~~~~~~~~~~~~~~~~~~~~~~~~~~~~

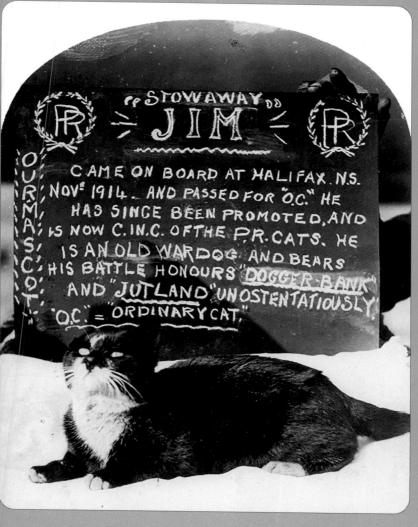

"STOWAWAY" JIM

CAME ON BOARD AT HALIFAX. N.S.
NOV. 1914. AND PASSED FOR "O.C." HE
HAS SINCE BEEN PROMOTED, AND
IS NOW C.IN.C. OF THE P.R. CATS. HE
IS AN OLD WARDOG AND BEARS
HIS BATTLE HONOURS "DOGGER BANK"
AND "JUTLAND" UNOSTENTATIOUSLY.
"O.C." = "ORDINARY CAT."

OUR MASCOT.

Stowaway Jim of HMS *Princess Royal* was a veteran of major naval
engagements during World War I. Human stowaways usually received
harsh treatment when discovered, but cat stowaways were almost
always welcomed.

(Author's collection)

~~~~~~~~~~~~~~~~~~~~~~~~~~~~~

*J*ust like the protagonist of Edward Everett Hale's classic short story, "The Man without a Country," an unknown number of vagrant cats spent their lives transferring from ship to ship, never having a true homeland. Over the course of its maritime life, a cat could sail the seas under several names after wandering onto new ships and being adopted by crews serving different nations.

~~~~~~~~~~~~~~~~~~~~~~~~~~~~~

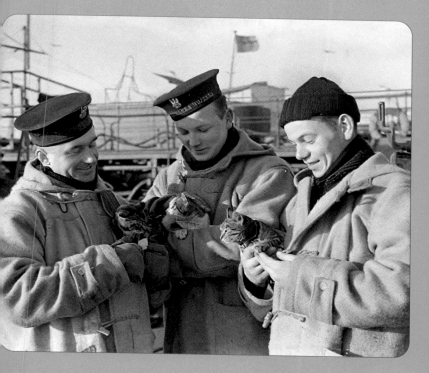

Polish cats Zaba (Frog) and Tygrys (Tiger) of the destroyer ORP
Piorun get acquainted with a cat that slipped on board from a British
ship, 1940. The *Piorun* later had a brief duel with the feared battleship
Bismarck, but neither ship scored a hit.

(U.S. Naval Institute photo archive)

~~~~~~~~~~~~~~~~~~~~~~~~~~~~~~~

*T*o track cats and identify vagrants that managed to slink onto ships without a medical exam, the Royal Navy once tried to implement a regulation requiring all mascot cats to wear collars embroidered with the name of the vessel to which they were assigned. Whether it was due to the cost of the collars or the realization that cats do not follow rules and would continue to change ships at will, the official collar regulation was short-lived.

~~~~~~~~~~~~~~~~~~~~~~~~~~~~~~~

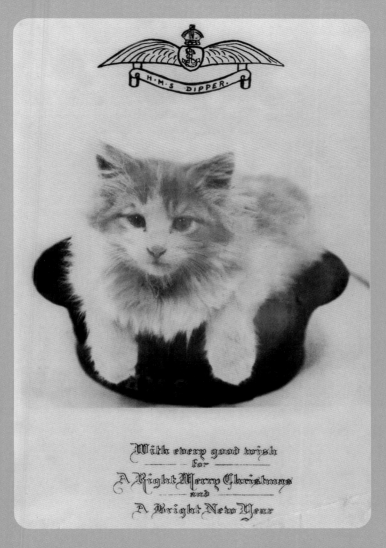

A kitten adorns a Christmas card for HMS Dipper (circa 1944), a Fleet Air Arm base in Dorset. The base featured an airstrip designed as a duplicate of the deck of HMS *Implacable*, and was used to train pilots for aircraft carrier landings.

(J&C McCutcheon Collection)

*I*t might seem odd for an animal with a notable contempt for water to spend its days traveling the open ocean, but cats are perhaps more naturally suited for life on the sea than humans. Sailors suffered from scurvy if they did not have access to fresh fruits and vegetables rich in vitamin C. Cats, on the other hand, can produce their own vitamin C, which enables them to live quite happily on a diet consisting almost exclusively of fish. Cats can also survive with less fresh water because they get some of the moisture they need from their prey. Additionally, their kidneys are effective at filtering salt, giving them the ability to drink limited amounts of seawater for a short time.

Crew of the USS *Nahant* play with their two cats, circa 1898. At the time, the *Nahant* was performing coastal defense duties to protect New York Harbor from a potential attack by Spanish forces during the Spanish-American War.

(Library of Congress)

~~~~~~~~~~~~~~~~~~~~~~~~~~~~~~~~~~~~~~~~~~~~~~

*A* few cats adapted so well to life at sea that they lost any fear of water and learned to modify their hunting techniques. The mascot of HMS *Pallas* would sit on the edge of the deck and dive into the water when it spotted fish. One crew member proudly reported that the aquatic cat rarely returned without a good-sized catch. Cats that preferred to stay dry became proficient at leaping up from the deck to knock down flying fish passing over the ship.

~~~~~~~~~~~~~~~~~~~~~~~~~~~~~~~~~~~~~~~~~~~~~~

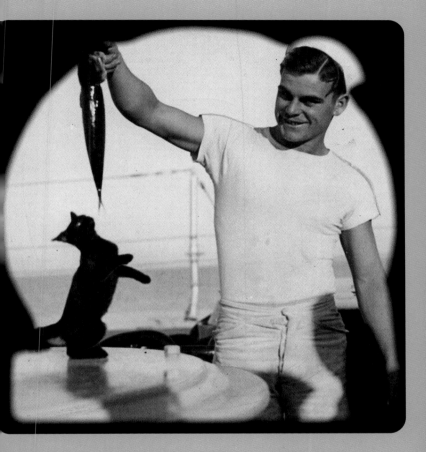

Perhaps this cat was too lazy, inexperienced, or unlucky to get its own fish, so a sailor on the battleship USS *California* shares his fresh catch, 1931.

(Author's collection)

While many cats became so accustomed to the conditions on a rocking ship that they quickly became furry four-legged sailors, others were slow to start prowling among the wave tops due to seasickness. Their human shipmates tried to remedy this by making tiny hammocks modeled after their own. Not only did a hammock help ease the swaying motion of the ship, but it also made the cat seem like a true member of the crew.

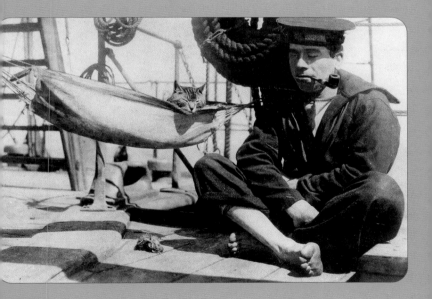

A Canadian Volunteer Reserve sailor on board HMCS *Rainbow* tends
to the ship's seasick cat, circa 1915. Hopefully the cat was well enough
to perform its duties for *Rainbow*'s important mission to transport
$140 million in gold from Russia to Canada for safekeeping during
the Russian Revolution.

(Author's collection)

s mascots, cats were considered more loyal to their ships than dogs, because cats tend to be more territorial and often chose to stay with a ship even as the crew changed. Dogs, on the other hand, are inclined to be loyal to an individual and thus would leave the ship once "their" sailor was reassigned. If a cat felt safe and was satisfied with the available food, it might choose to remain on a ship longer than any other member of the crew. The Siamese cat Princess Truban Tao-Tai had become so comfortable after sixteen years as the mascot of the British cargo ship *Sagamore* that a special clause permitting her to remain was included in the contract when the vessel was sold to an Italian company in 1976.

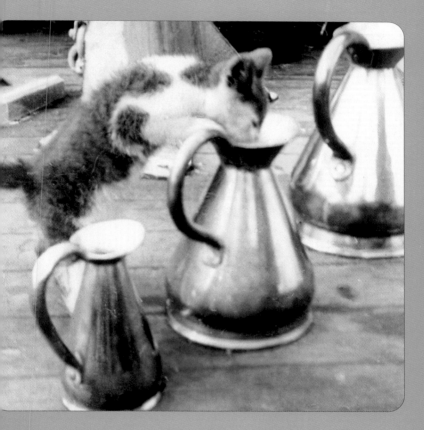

The mascot of HMCS *Wasaga* getting a taste from the measures used to distribute the rum ration, circa 1943. The Royal Canadian Navy abolished the daily tot in 1972.

(Roger Litwiller Collection, courtesy Ross Milligan)

~~~~~~~~~~~~~~~~~~~~~~~~~~~~~~~~~~~~~~~~~

*B*ecause a cat usually belonged to the entire ship (or, perhaps more accurately, the entire ship belonged to the cat), crew members were designated as caretakers responsible for ensuring the mascot was fed and healthy. If the cat was not already on the ship's payroll and earning its keep as an effective mouser, the crew would contribute to a special fund to supply the mascot with all its needs. Some cats became so spoiled that they enjoyed amenities not afforded the rest of the crew, such as plush private quarters.

~~~~~~~~~~~~~~~~~~~~~~~~~~~~~~~~~~~~~~~~~

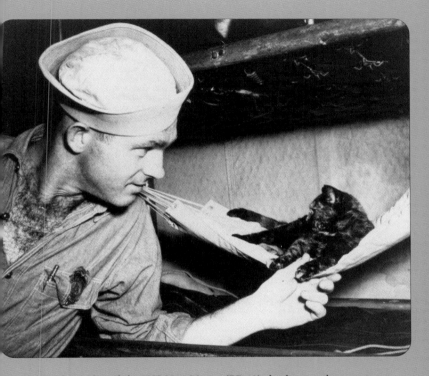

A sailor on board the USS *New Mexico* (BB 40) checks to make sure the new ship's cat, Saipan, is comfortable, circa 1944. The mascot was possibly captured from the Japanese following the Battle of Saipan.

(U.S. Naval Institute photo archive)

*M*onkeys were also popular mascots with sailors, but many commanding officers allowed only cats because the mischievous primates were a constant distraction on a ship. Much time was wasted chasing monkeys that had scampered away after snatching sailors' hats. Captains also preferred cats to parrots because sailors would teach the birds to curse and insult officers. In fact, parrots were prohibited by the U.S. Navy in 1930 due to concerns over the spread of psittacosis—at least, that was the official reason for the ban, but sailors suspected it was actually due to the chatty birds' ability to ruffle the officers' feathers.

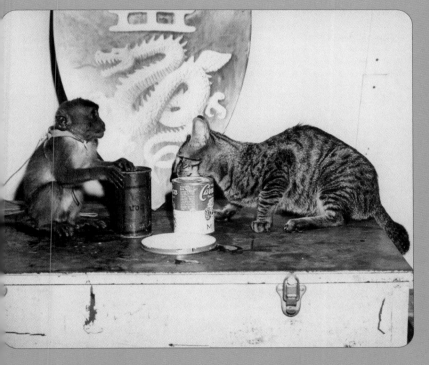

Combat the cat has lunch with the monkey mascot of the U.S. Marine III Amphibious Corps, 1945. Even though they could be a nuisance, monkeys on ships outlasted actual powder monkeys—young boys who, until the early twentieth century, were primarily tasked with scrambling through a ship to carry gunpowder from the magazine to the guns.

(From the collection of William T. Swisher, Marine Corps Archives & Special Collections)

*B*ig ships might house several cats, who in turn seemed to develop a system of dividing territory so that each cat had its own deck to patrol. The cats (perhaps the most intelligent ones) that claimed the galley did not have to work very hard for food. Spoiled by the cooks, these galley cats often were the fattest on the ship. Other cats reigned over the laundry room, which was warm and filled with soft bedding. A diligent and efficient rat catcher could eventually rise above the other cats by being promoted to official ship mascot—a position that brought the added benefit of extra attention.

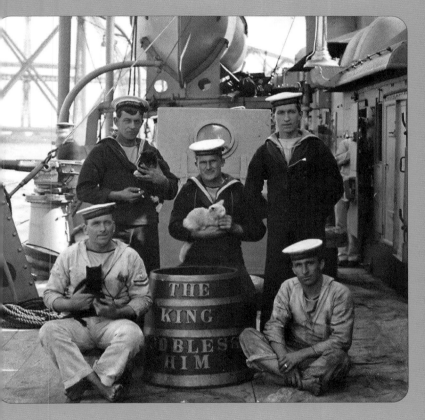

Arthur Pidgeon and other Royal Navy sailors pose by the rum barrel with the cats of HMS *Sentinel*, 1914. The same year this photo was taken, the consumption of alcohol was banned on U.S. Navy ships.

(Courtesy of Dr. Ruth J. Salter)

or decades the Brooklyn Navy Yard was the home of many of the U.S. Navy's cats. At one point, at least 1,500 feral felines stalked the shipyard. The Brooklyn cats became prized acquisitions for ships in need of mascots because, in addition to being exceptional rat catchers, they were known to be particularly ornery and territorial. They were regularly observed acting as a team to attack mascots from visiting ships that dared to venture onto their yard.

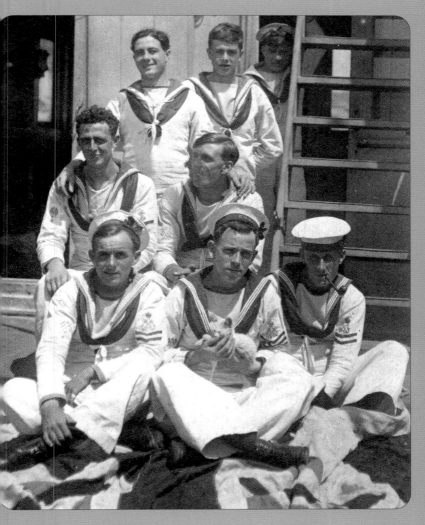

Sailors of the armored cruiser HMS *Nelson* pose with a kitten, circa 1890. Cats have a noted dislike for certain smells, but they seemed to tolerate British sailors, who sometimes smelled of citrus because of the Royal Navy's practice of making sailors drink lime and lemon juice to prevent scurvy.

(Author's collection)

~~~~~~~~~~~~~~~~~~~~~~~~~~~~~~~~~~~~~~~~~~~

*I*mages of mascot cats sitting in the muzzles of ships' guns are common. Not only did photographers think it was a fitting pose, but many cats also discovered that the gaping opening of a gun was the ideal location for a nap. The guns provided a quiet, cool shelter where cats could watch the daily activities of the sailors on the deck or sleep without being disturbed.

~~~~~~~~~~~~~~~~~~~~~~~~~~~~~~~~~~~~~~~~~~~

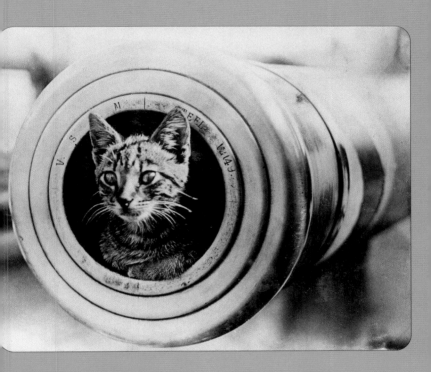

A cat peeks out of the muzzle of a 6-inch gun on HMAS *Encounter*, circa 1916.

(Australian War Memorial)

~~~~~~~~~~~~~~~~~~~~~~~~~~~~~~~~~~~~~

*P*iles of ship bunting could be irresistible to cats searching for a comfy spot to snooze. Several sailors told tales about raising bunting and then having to lower the lines quickly when they spotted a surprised cat dangling from one of the flags. Other cats that had squeezed themselves into the tight confines of a roll of canvas could be seen sliding across the deck after their sleep was rudely interrupted by the unfurling of the ship's sails.

~~~~~~~~~~~~~~~~~~~~~~~~~~~~~~~~~~~~~

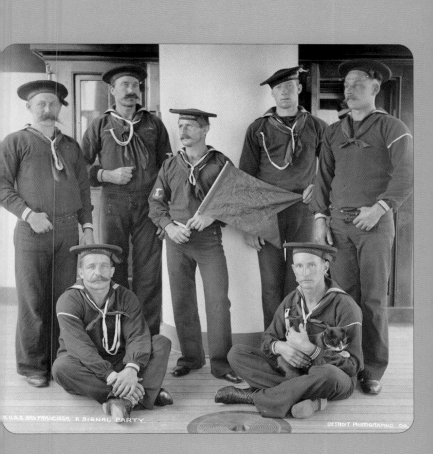

A signal party from the USS *San Francisco* with the ship's cat, 1890.

(Library of Congress)

*A*s beloved as ship cats were for their predatory skills, their eagerness could prove to be a nuisance. During a voyage of scientific exploration of the Antarctic on board HMS *Terror* in 1842, the captain noted that they had the good fortune of a strange new species of fish washing onto the deck. Regrettably, before the specimen could be properly documented and preserved, the ship's cat pounced and ate it.

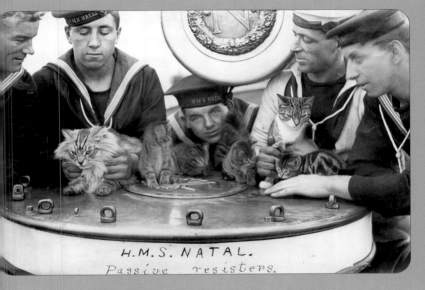

H.M.S. NATAL.
Passive resisters.

Sailors on board HMS *Natal* struggle to keep all seven of their passive
resisters stationary long enough to be captured by the camera, circa 1914.

(Author's collection)

~~~~~~~~~~~~~~~~~~~~~~~~~~~~~~~~~~~~~~~

*A*lthough the U.S. armed services have a long history of kidnapping each other's mascots as a prank, the Army recognized and respected the importance of cats on Navy ships. When the cruiser USS *Des Moines* deployed from Havana in 1907, the crew was despondent because they had been unable to find their cat after it strutted onto an Army arsenal days earlier. The arsenal's quartermaster caught the cat after the *Des Moines* was under way, then worked determinedly to locate the cruiser and have the prized mascot express delivered by another ship.

~~~~~~~~~~~~~~~~~~~~~~~~~~~~~~~~~~~~~~~

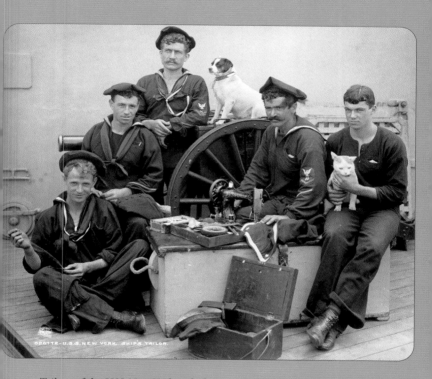

Tailors of the USS *New York* with their cat and dog, circa 1898. Tailors often made uniforms for their mascots. The modern U.S. Navy still has tailors, but their rating is now Retail Service Specialist.

(U.S. Naval Institute photo archive)

The diverse mascots on board the USS *New York* included a fawn, a cat, two dogs, and a goat. Prior to the 1930s, it was not unusual for ships to have a menagerie of mascots.

(Author's collection)

Cats and other mascots of the U.S. Navy Atlantic Fleet received a swift dishonorable discharge in 1913 after a goat repeatedly butted Rear Admiral Robert Doyle as he inspected the USS *New Hampshire*. The goat's flagrant lack of respect prompted the commander of Norfolk Navy Yard to immediately ban all pets on ships. Assistant Secretary of the Navy Beekman Winthrop disapproved of the ban and reinstated the mascots a few days later.

A pair of H.M.S. "Dreadnoughts" guns with "Togo" the cat. No. 9

Togo the cat on the guns of the revolutionary battleship HMS *Dreadnought*, circa 1914. After the *Dreadnought* was launched in 1906, all nations that aspired to be a sea power rushed to build their own versions.

(J&C McCutcheon Collection)

*D*uring World War I, the British War Office enlisted half a million cats to rid trenches and ships of rodents. To raise such a large force of cats, the government awarded contracts to individuals to round up the thousands of strays roaming British cities. Cats assigned to the Royal Navy were paid 1 shilling and 6 pence every week as a victualling allowance in case they were too efficient in clearing rats and needed a meal from the canteen.

~~~~~~~~~~~~~~~~~~~~~~~~~~~~~~~~~~~~~~

*W*hen the crew of a U-boat torpedoed and then boarded the supply ship SS *Texel* in 1918, the frantic merchant sailors pleaded with the German commander to allow them to search for their cat, Mickey, before the ship sank. The commander granted their request, and the sailor managed to find Mickey and get him safely into a lifeboat. During the war, an animal rights group awarded cats and other mascots a special torpedo pin if they survived the sinking of a ship caused by a U-boat.

~~~~~~~~~~~~~~~~~~~~~~~~~~~~~~~~~~~~~~

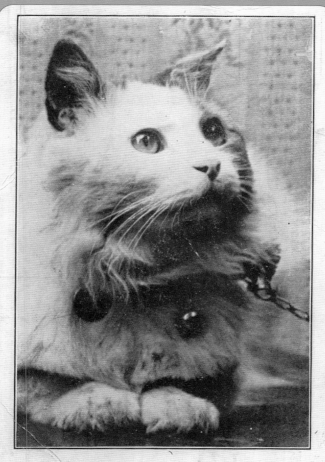

"JIMMY" OF H.M.S. "RENOWN."
Wounded at the Battle of Jutland and now in the care of
our Dumb Friend's League, Chelsea Shelter, 20, Bywater St.,
King's Road, Chelsea.

While serving as mascot on HMS *King George V*, Jimmy the cat suffered an ear wound during the Battle of Jutland in 1916. He later transferred to HMS *Renown* before becoming the furry face of a fundraising campaign for the Our Dumb Friends League, a UK-based animal welfare organization now known as Blue Cross.

(J&C McCutcheon Collection)

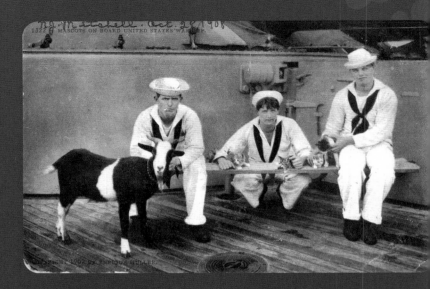

Cats outnumbered goats by four to one on this U.S. Navy ship, 1907. This reflected the trend of felines becoming the most popular mascot of the period.

(Author's collection)

*I*n the 1920s cats replaced goats as the most common mascot on U.S. Navy ships. Like cats, goats served a practical role while also providing entertainment for the crew. Goats produced fresh milk for cheese and butter, and were also a source of meat, leather, and fiber. They functioned as garbage disposers by eating any scraps given to them. But the goats' role in the Navy diminished as methods for preserving ships' supplies improved. Nevertheless, their historic relevance is reflected in the United States Naval Academy's official mascot, Bill the Goat.

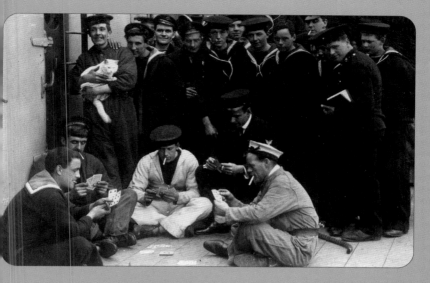

This postcard from HMS *Caroline* captures four of the favorite activities of off-duty sailors—gambling, smoking, reading, and playing with the mascot, 1916.

(Author's collection)

*I*n the United Kingdom, ships' cats were granted a special privilege that recognized their importance. Under UK law, these cats were free to disembark and explore the British ports they visited, unbothered by bureaucratic red tape, whereas all other cats brought into the country by private citizens had to be quarantined for six months.

*I*n 1929 the American Legion launched the Association of Surviving Mascots of World War I to recognize the animals that had served overseas with U.S. forces and were still active. Members of the association included dogs, mules, horses, monkeys, bears, and even a deer, but no cats. The American Legion encouraged people to submit names of cats that qualified for membership, noting that cats had certainly been on Navy ships during the conflict. However, a decade had passed since the war ended, and it was unlikely that any such ships' cats were still alive. Prior to 1930 the life expectancy of a cat was eight years. Today, a cat's life expectancy has doubled to almost sixteen years.

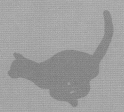

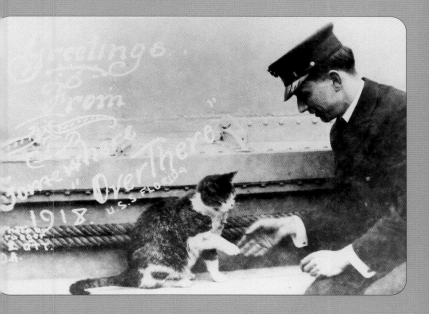

A postcard featuring the mascot of battleship USS *Florida* (BB 30), circa 1918. The *Florida* spent most of World War I reinforcing the British Grand Fleet "over there," in the North Sea.

(U.S. Naval Institute photo archive)

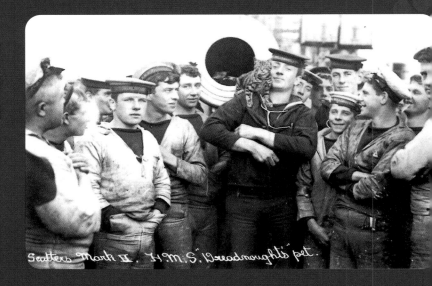

Scatters Mark II. H.M.S. "Dreadnought's" pet.

There is no record of the fate of the original Scatters, but the cat must have made enough of an impression on the crew of HMS *Dreadnought* that they chose to name their new mascot Scatters Mark II in 1908.

(Author's collection)

*P*erhaps not wanting to take a chance on a cat that could become lazy or skittish once at sea, ships preparing to deploy would occasionally place notices in newspapers requesting experienced rat catchers. The advertisements were sometimes specific about the types of cat wanted, listing desired breeds, sexes, colors, and sizes. A few ads even provided the name the cat would be given.

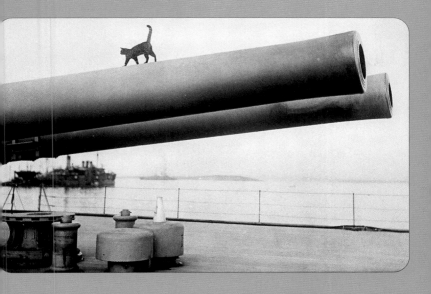

The mascot of HMS *Queen Elizabeth* struts along a 15-inch gun near Gallipoli, 1915.

(Australian War Memorial)

*A*fter decades of being rather tolerant in its policies, in 1931 the U.S. Navy began to restrict mascots. The era of big guns brought firepower that created such a mighty bang that the concussion could be fatal to small animals, and the noise alone drove some mascots to jump ship. Veteran mascots learned to recognize the crew activity that preceded the firing of guns, giving them time to rush belowdecks to find shelter from the thunderous booming.

~~~~~~~~~~~~~~~~~~~~~~~~~~~~~~~~~~~~~~~~~~~~~~~

*D*uring World War II the United Seaman's Service recognized the role of mascots and the dangers they faced in combat. The organization hosted a party in New York for veteran cats and other animals from ships that had been torpedoed, bombed, or strafed. The mascots' caretakers were given prizes of war bonds and pet food. Most mascots that received invitations had to send their regrets, however, because they were on duty.

~~~~~~~~~~~~~~~~~~~~~~~~~~~~~~~~~~~~~~~~~~~~~~~

A sailor attached to utility squadron VJ-4 plays with kittens that were discovered hiding in an equipment room at U.S. Naval Air Station Squantum in Massachusetts, 1942.

(NARA)

*I*n 1947 further controls were enacted for cats and other mascots. Secretary of the Navy James Forrestal issued a general order prohibiting any animals on ships that lacked documentation proving they were disease-free. Forrestal himself was known to be fond of his own cat, Mrs. Whiskers, but he was compelled by the Navy Bureau of Medicine and Surgery to issue the order.

It was not until they were in the air that the crew of this U.S. Coast Guard PBY noticed that Salty the cat had crept on board with her kittens, 1945.

(NARA)

In the 1950s, during U.S. congressional debates over appropriations bills, proponents of major defense budget cuts would cite the continued presence of cats on ships in an attempt to embarrass the Navy. The Navy was ridiculed for having such an excess of resources that money and labor were being expended on events deemed frivolous, such as elaborate funerals for ships' cats. The Navy responded by placing tighter restrictions on all pets, a practice that continues to this day.

A kitten wears a custom U.S. Navy Cracker Jack uniform in 1950. The traditional uniform got its nickname when the Cracker Jack snack food mascot, Sailor Jack, became ubiquitous during World War I.

(NARA)

~~~~~~~~~~~~~~~~~~~~~~~~~~~~~~~~~~~~~~

The current U.S. Navy policy directive states, "NO PERSON SHALL HAVE IN THEIR POSSESSION OR BRING ABOARD A NAVAL UNIT ANY ANIMALS FOR ANY PURPOSE WHATEVER, WITHOUT PERMISSION OF THE COMMANDING OFFICER."[1] While it may be possible for a Navy ship to have a cat, it is unlikely that a commanding officer would grant such permission.

~~~~~~~~~~~~~~~~~~~~~~~~~~~~~~~~~~~~~~

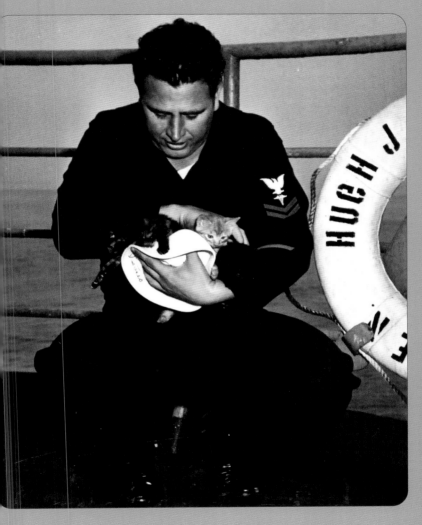

A Navy hospital corpsman has a hat full of kittens on the transport USNS *General Hugh J. Gaffey*, 1951. The ship was used to transport the families of servicemen who were stationed overseas, so the cats may have provided entertainment for children.

(NARA)

~~~~~~~~~~~~~~~~~~~~~~~~~~~~~~~~~~~~~~~~~~~

On the other side of the Atlantic, the Rabies (Control) Order 1974 essentially served as the separation papers for cats in the Royal Navy. Even ship mascots were no longer allowed to enter the United Kingdom without being placed in quarantine first. In 1977 the General Council of British Shipping followed suit by ordering the UK's merchant vessels to retire all cats.

~~~~~~~~~~~~~~~~~~~~~~~~~~~~~~~~~~~~~~~~~~~

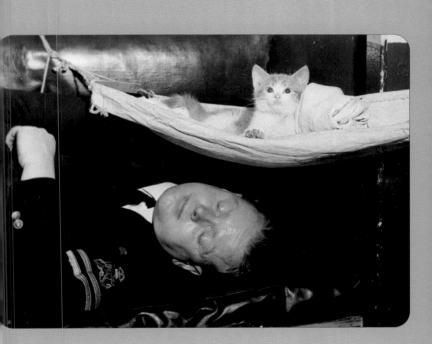

A Royal Navy petty officer on HMS *Howe* obviously needs some sleep, but his bunkmate looks bright-eyed and bushy-tailed, 1946.

(Author's collection)

Kitty Mollie

Sing a song of Bluejackets, fighting on the sea;

How I love them, every one! They're so good to me.

I'm the only kitty-kat on this great big boat,

With its doggy mascots and its funny "ba-ba" goat.

When I jump on Billie's back for to take a ride,

Billie sees a periscope, then off his back I slide;

For Billie has a dreadful way of butting at a Hun,

And after Billie's butted, why, we just fire off a gun![2]

Sheet music for the piano solo "The Ship's Cat" by Elinor Colby, published in 1953.

(Author's collection)

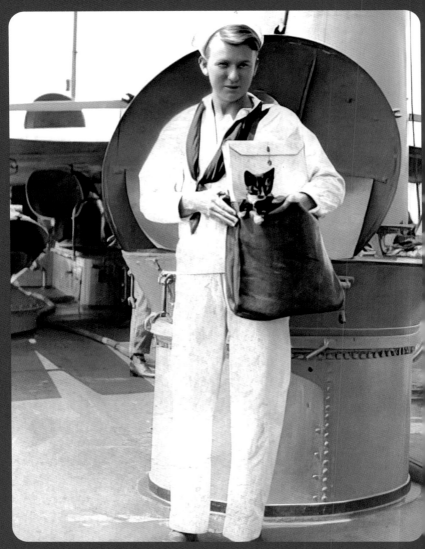

Mail call on ships has always been an important event to maintain crew morale. The spirits of the sailors on this unnamed ship probably received an additional boost when their mail was delivered with the help of a cat, circa 1917.

(Author's collection)

PART II

The Many Roles
of the
Ship's Cat

Pest Control

～～～

The first and foremost role of a ship's cat was to exterminate the rodents that spread disease and threatened the food supply. Cats have been very efficient at pest control since they first became domesticated around 10,000 years ago. A study of cat DNA revealed that the first wave of domesticated cats accompanied farmers from the Middle East and stretched across Eurasia.[3] The same study showed that the second wave originated in Egypt but was boosted over the centuries by the Vikings. The Vikings valued the mice-catching skills of cats and brought them on far-reaching journeys, introducing them to many regions in both the old and new worlds.

"Brönnhilde"

A novelty photo of a Viking cat, 1936. In Norse mythology, the goddess Freya rides in a chariot pulled by two cats given to her by Thor.

(Library of Congress)

Morale

~~~~~

Sailors deployed for months—sometimes years—on a ship that was thousands of miles from home could become demoralized and slip into depression. Cats and other mascots offered affection and a bit of serenity in an environment that was otherwise somewhat comfortless. Mascots could remind sailors of childhood pets and ease homesickness. Because the mascot was shared among the crew, it helped create a bond between sailors across all sections of the ship.

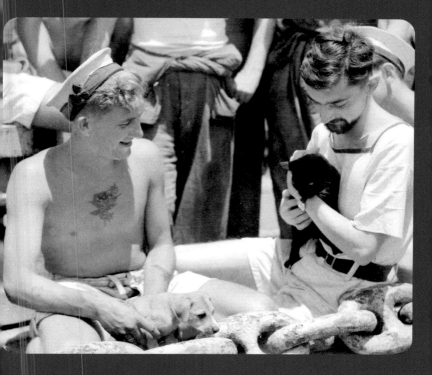

Salvo the cat keeps a close eye on Shrapnel the dog on board HMAS *Sydney*, 1940. Perhaps unsurprisingly, kangaroos were also popular mascots on Australian ships and were often presented to American ships that visited Down Under.

(Australian War Memorial)

# Storm Warning

*P*articularly superstitious old salts used to say, "Every cat carries a gale in its tail"—a gale that would soon be unleashed when a cat became irritated (which is why the tailless Manx cat was a favored mascot). In reality, though, cats simply were reacting when their sharp senses detected shifts in atmospheric pressure. Sailors noted that cats would become agitated even before the barometer dropped to indicate an approaching storm. This is why changes in cats' behavior were closely observed. Scratching and licking the wooden deck, unusual grooming routines, and increased twitching of ears were interpreted as warnings of impending squalls.

Fittingly, HMS *Manxman* adopted a tailless Manx kitten to serve as
the ship's mascot in 1963. In the nineteenth century it was incorrectly
theorized that the tuft of fur on a Manx's backside indicated that it
was actually a cat-rabbit hybrid known as a cabbit.

(Author's collection)

# *Air-Raid Warning*

With the evolution of warfare, sailors were always discovering new benefits of having a ship's cat. During World War II, cats could function as effective early-warning air-raid alarms because their acute hearing enabled them to detect the faint whines and drones of approaching aircraft. The crew learned to scan the skies when they saw cats flinching before hurriedly seeking cover deep within the ship.

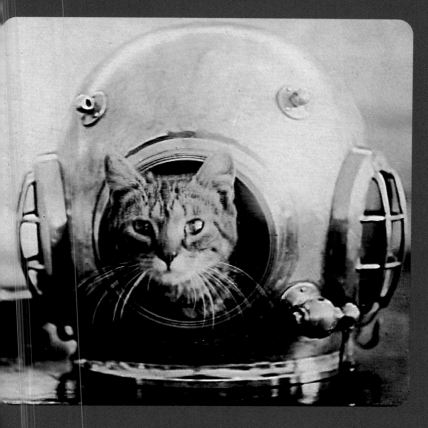

The mascot of HMS *Black Prince* appears to have found a secure spot to wait out an attack. Tragically, the *Black Prince* lost contact with the Royal Navy fleet during the Battle of Jutland and was sunk at night after mistaking a line of German ships for British ships.

(Author's collection)

# Companionship

*B*eing a sailor on long voyages was hard and often lonely work, so cats were a welcome distraction during quieter times. Because of the affection and respect given to cats, early animal rights groups lauded sailors for their humane treatment of their mascots. Sailors became so attached to their feline friends that they were willing to risk their own lives for their cats' sake. It was considered bad luck to abandon a mascot, and there are numerous accounts of sailors refusing to leave sinking or burning vessels until they had found their feline friends. The Our Dumb Friends League awarded silver medals to the sailors who had saved cats from HMS *Ark Royal* after the aircraft carrier was torpedoed in 1941.

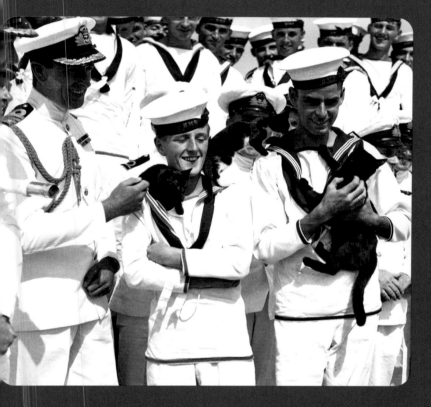

Lord Mountbatten inspects the cats of HMS *Illustrious* while the ship
was in Norfolk, Virginia, for repairs in 1941. One of the cats was
named Taranto in honor of the Royal Navy's successful raid on Italian
naval forces at the coastal city of the same name.

(Courtesy of Sargeant Memorial Collection, Norfolk Public Library, Virginia)

When the USS *Leyden* foundered in heavy fog in 1903, the first words of a sailor who had been resuscitated were, "Did they save Tiger?" referring to the tug's beloved mascot. Happily, Tiger had indeed been rescued. In another instance, at least one sailor took his devotion to the ship's cat to an extreme. A report states that after a captain refused to rescue a cat that had fallen into the sea, a sailor threw himself overboard to force the ship to turn around. Both sailor and cat were saved. The report does not include any information about the consequences the sailor faced for his actions.

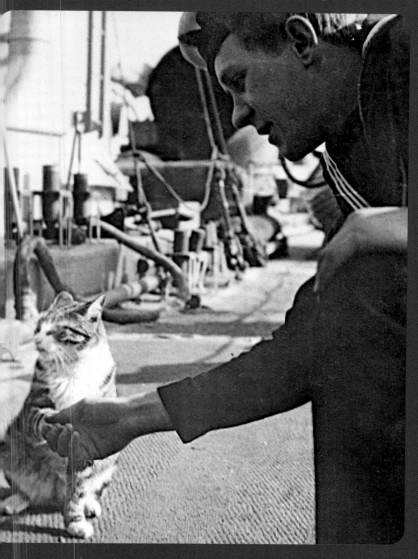

An Australian sailor on HMAS *Swan* shakes the paw of ship mascot Ching, circa 1917. Ching appears to be an average-sized cat, unlike the giant phantom cats that are purported to roam Australia, but whose existence has never been confirmed.

(Australian War Memorial)

# *Souvenirs and Trophies*

*M*ascot cats were often gifts from the people of the ship's namesake city or region. Others were presented by officials in foreign ports as symbols of good international relations. Sailors visiting exotic lands also liked to pick up unusual breeds of cats to take back home. Perhaps the cats that gave the crew the most pride were those captured from an enemy. The U.S. Navy once touted the number of cats in its employ that had been taken from defeated ships during the Spanish-American War. Cats taken from German ships by Allied navies in World War I were likely to be named Kaiser, and Adolf was a common name for cats liberated from the Kriegsmarine during World War II.

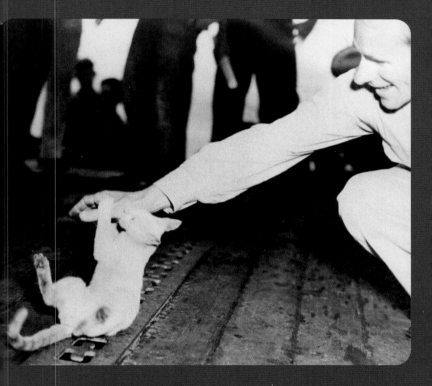

The USS *Langley*'s only captured prisoner on its first battle cruise was this cat found on Majuro atoll, 1944. There is no record of the cat's name, but Tojo was the moniker commonly given to mascots liberated from the Japanese.

(NARA)

~~~~~~~~~~~~~~~~~~~~~~~~~~~~~~~~~~~~~~~~~

*S*hips that logged thousands of nautical miles sometimes accumulated so many souvenir cats in various ports that they could boast of having a large international crew of mascot mousers. In 1922, the USS *Mississippi* had no fewer than thirteen cats that had been acquired in China, India, Spain, the United States, and a few other countries that the sailors could not recall.

~~~~~~~~~~~~~~~~~~~~~~~~~~~~~~~~~~~~~~~~~

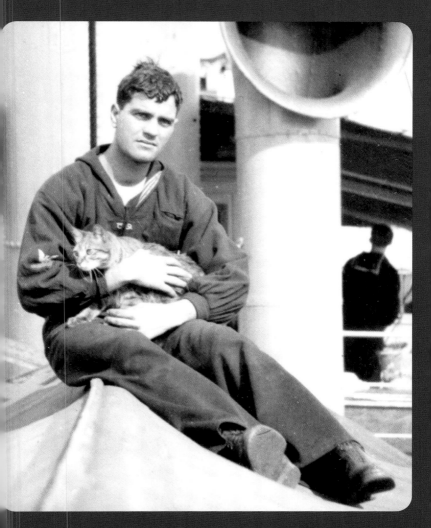

Sailor with the ship's cat on the USS *Villalobos*, circa 1907. The *Villalobos* was assigned to the Yangtze River Patrol at the time of this photo and later inspired the ship featured in Richard McKenna's novel, *The Sand Pebbles*, and the subsequent movie of the same name starring Steve McQueen.

(Naval History and Heritage Command)

# *Ship Representatives*

Cats and other mascots frequently became the representatives of warships and helped give the stark vessels a bit of character. During World War I postcards of ships' mascots were commonplace and widely shared by sailors with their family and sweethearts because the images presented a softer perspective of life at sea. The postcards regularly featured a photo of the mascot framed by a life preserver emblazoned with the ship's name.

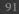

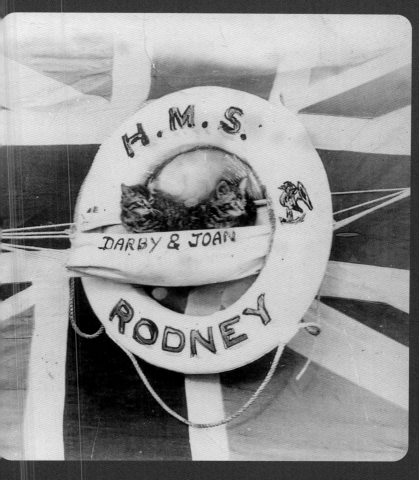

Darby and Joan of HMS *Rodney*, circa 1890. The *Rodney* was the last British battleship to have a figurehead. By becoming a ship's symbol, mascots took over one of the main functions of figureheads.

(J&C McCutcheon Collection)

# Fundraisers

*I*n the early part of the twentieth century, the size, firepower, and technical advancement of battleships became a source of national pride. In the UK, the Royal Navy's battleships often achieved celebrity status. Because the public was eager to have a connection to iconic ships such as HMS *Dreadnought* and HMS *Iron Duke*, kittens produced by those ships' cats became popular prizes in raffles held to raise money for various sailors' funds.

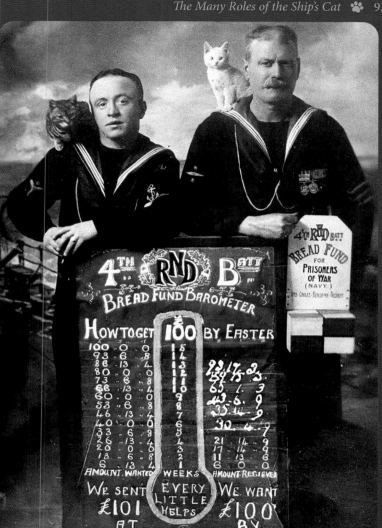

Postcard of sailors with cats promoting a fund to send white bread to British prisoners of war who disliked German black bread. At least a few prisoners of war who escaped and tried to mingle with the local populace were captured when they were seen eating white bread.

(Author's collection)

# *Pastime*

~

*P*rior to the nineteenth century, many sailors lacked a formal education and were illiterate. Unable to read or write, they resorted to other activities to relax and keep themselves entertained when off duty. Wood carving and embroidery were typical hobbies, but sailors who enjoyed a real challenge might spend long deployments attempting to train the ship's cat to do tricks.

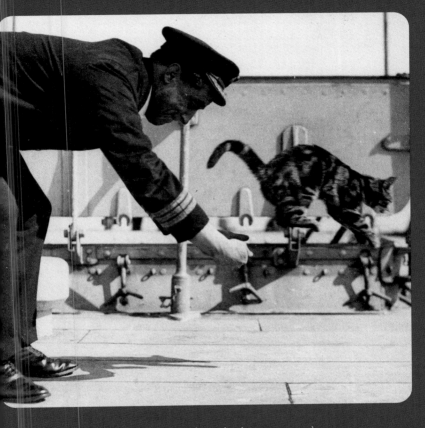

An officer teaches a cat to jump through a hoop on an unknown
Royal Navy ship, circa 1916. A short jump through a hoop is a simple
feat for most cats. Cats can jump up to six times their length and five
times their height.

(NARA)

# Survival

*I*f a ship sank or was adrift, a cat could help crew members survive. Stories abound of cats providing food to starving sailors by catching rats and fish. The crew of a torpedoed merchant ship who had spent three days adrift in a lifeboat credited the ship's cat, Maizie, with saving their lives as they struggled against exposure and seasickness. One of the sailors said that without Maizie comforting each of them, they might have lost their sanity. Some sailors also believed that cats would assist them in spotting rescue ships at night because their keen nocturnal vision enabled them to see lights too distant for the human eye to perceive.

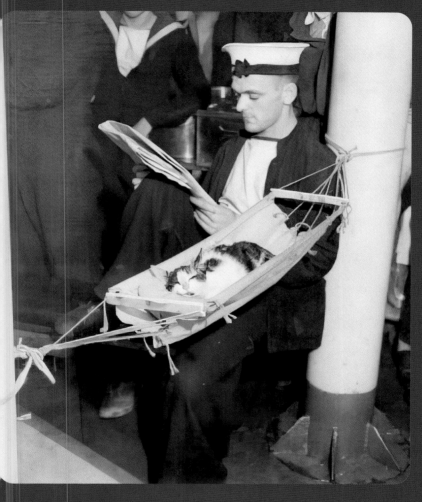

A veteran of several patrols, Convoy the cat rests in his hammock on board HMS *Hermione*, 1941. As much as sailors loved their mascots, they likely would be envious that cats can sleep as many as sixteen hours a day.

(U.S. Naval Institute photo archive)

# *Salvage Protection*

Commercial vessels that were wrecked and abandoned were subject to salvage if no life was found on board. In 1275 King Edward I decreed, "Where a man, a dog, or a cat escape quick [i.e., alive] out of the ship, neither that ship nor barge, nor any thing in them shall be adjudged a wreck."[4] Both British and American courts continued to recognize the law into the twentieth century. Knowing this, captains often brought cats on board so that they would be able to recover their ships and cargo if an emergency forced the crew to vacate the vessel. Many salvage operations expecting a big payout after towing an ostensibly abandoned ship to port were surprised and dismayed to learn that they would have to forfeit their prize when a cat emerged from a hiding place.

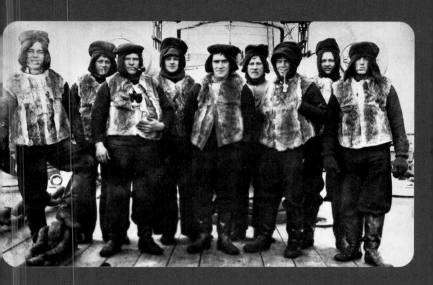

A sailor on board HMAS *Australia* in the North Sea keeps a cat warm
by tucking it into his cold weather gear, circa 1915.

(Australian War Memorial)

~~~~~~~~~~~~~~~~~~~~~~~~~~~~~~~~~~~~~~~~~~~~~

A ship cat's hidey-hole, which could guarantee a living creature remained on board to thwart salvage attempts, was also a potential liability on illicit vessels. During Prohibition, federal agents learned to immediately look for the cat when they boarded suspected rumrunners. The panicked cat often led the agents to the illegal cargo by darting off to hide in the secret compartment holding the hooch.

~~~~~~~~~~~~~~~~~~~~~~~~~~~~~~~~~~~~~~~~~~~~~

Australian seaman with a cat and kitten, circa 1910. Even the saltiest and crustiest of sailors could feel comfortable revealing their soft side when spending a few minutes with the ship's cats.

(Australian National Maritime Museum)

# *Insurance*

~~~~~

On merchant vessels, marine insurance generally did not cover damage to cargo caused by rodents. Any goods that were destroyed by rats had to be written off as a loss. However, the owner of the cargo could seek compensation from the ship's owner if no cat was present to check the rodent population during the voyage. Even a lazy cat that was a poor mouser was enough to allow the ship's owner to avoid culpability.

Looking like the cover of a romance novel or an advertisement for cologne, a pipe-smoking Dutch sailor sits with a kitten on his shoulder, 1912.

(NARA of the Netherlands)

Enforcers

*C*ats of a certain temperament could act as ship enforcers to keep other mascots in line. When monkeys, dogs, or goats became too rambunctious, cats would stare them down and occasionally take a disciplinary swipe or two. The twenty cats serving on the USS *Minnesota* in 1913 met their match, however, when eight monkeys purchased in Mexico decided to fight rather than submit to their feline overlords. The monkeys gained the upper hand, but the hissing and howling battle cries became so great that Marines were called in to capture the rebellious simians and rescue the cats.

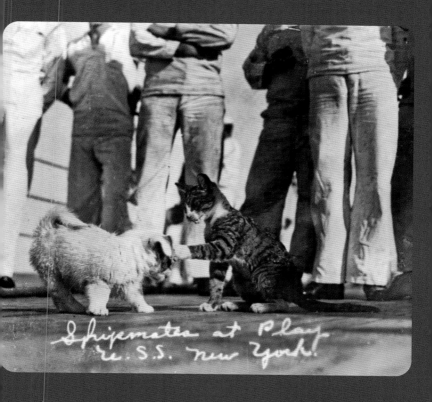

The USS *New York*'s cat takes a playful swipe at the ship's dog, circa 1918.

(Author's collection)

Deception

~~~~~~~~

*W*hen crews needed to hide the identity of their ships in false-flag operations, cats could be useful props. During World War II, the Royal Navy altered HMS *Manxman* to resemble a French cruiser so it could conduct a mission near Vichy, France. To make the ruse more convincing to passing enemy planes, sailors wore French uniforms and even dressed the ship's mascot in a tricolor jacket and cockade to disguise it as a French cat.

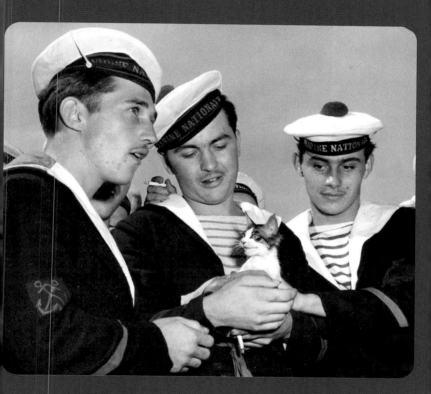

This cat does not seem to approve of these French sailors having a smoke as they wait in Seattle to take over ships given to France by the U.S. Navy under the Defense Aid Pact, 1950.

(U.S. Naval Institute photo archive)

# Sentries

~~~~

*L*ike a ship's detachment of Marines, cats worked as sentries, prepared to raise the alarm and repel any boarders they sighted. Rats and mice were not the only animal intruders that threatened a ship. Foxes, skunks, raccoons, possums, snakes, and other potentially diseased or venomous creatures had to be kept from boarding. If cats were unable to eliminate the threat themselves, their screeching alerted the crew to the presence of the stowaways.

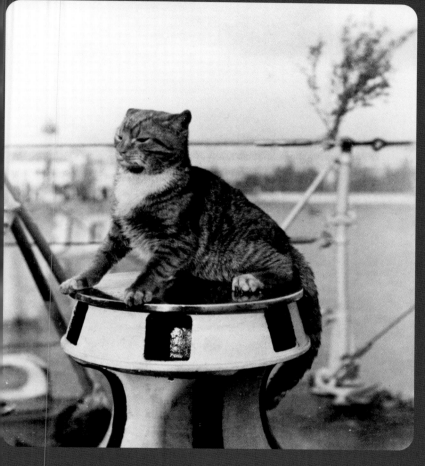

Wockle, the cat of the USS *Flusser*, shows his war face while sitting atop a capstan, circa 1924.

(U.S. Naval Institute photo archive)

Lucky Charms

~~~

Sailors have long thought that cats brought good luck. Although some cultures have viewed black cats negatively, they were cherished by the Royal Navy as bearers of good fortune. Seamen knew that good fortune was fragile, and any abuse toward a cat would result in the ship being jinxed. Ships could be beset by fires, food might spoil, supplies could be swept overboard, shipmates who had been close friends might suddenly break into violent fights, and ships could run aground. To preserve the ship's good luck, any sailor caught mistreating the ship's cat was severely punished.

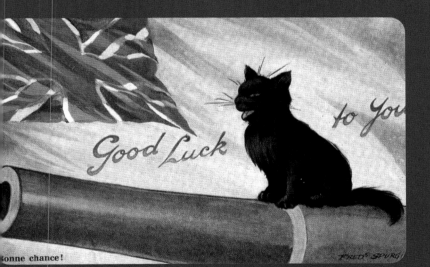

The sender of this postcard hoped that the black cat on the gun would bring the recipient good luck during World War I.

(Author's collection)

~~~~~~~~~~~~~~~~~~~~~~~~~~~~~~~~~~~~~~~~~~~

*P*olydactyl cats were considered especially lucky. Whether because they were superior rat hunters, had better balance on a pitching ship, or simply brought additional good fortune, cats with extra toes were favored by sailors. Author Ernest Hemingway's famous clowder of polydactyl cats at his house in Key West, Florida, originated when he received his first one from a ship's captain.

~~~~~~~~~~~~~~~~~~~~~~~~~~~~~~~~~~~~~~~~~~~

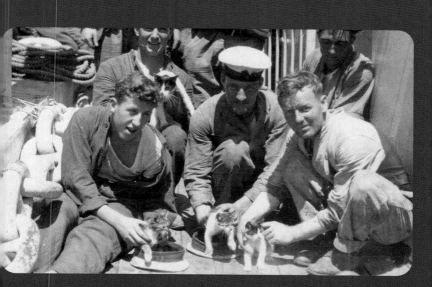

The sailors of HMS *Cyclops* were perhaps trying to quadruple their luck with these four cats, circa 1930.

(Author's collection)

# Omens

Sailors believed a ship was doomed if their cat was seen carrying her kittens down the gangplank to the pier before getting under way. Jittery crew members would recall all the sea stories they had heard about ships foundering after the cat suddenly decided to disembark. In an effort to safeguard their future, sailors rushed to retrieve any cats that made a last-minute dash to shore. The crew's anxiety would increase when repeated attempts to contain the cat on board the ship were foiled by a mascot's determination to slip away.

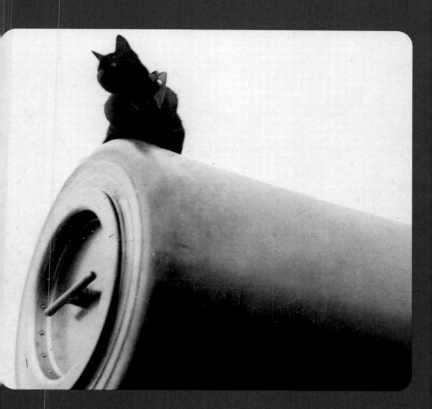

HMS *Barham*'s cat stands watch atop a 15-inch gun, circa 1915.

(Author's collection)

~~~~~~~~~~~~~~~~~~~~~~~~~~~~~

*I*n 1942, sailors saw HMS *Wild Swan*'s cat dive into the water and swim furiously toward another ship. As soon as the cat had been rescued and returned to the *Wild Swan*, she plunged back into the water. She was fished out of the sea, only to again escape and paddle her way onto the other ship. The crew decided there was no changing the cat's mind, so they set off without her. Days later, the *Wild Swan* came under air attack and then sank after colliding with a trawler.

~~~~~~~~~~~~~~~~~~~~~~~~~~~~~

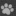

It was wise for these sailors of HMS *Royal Sovereign* to keep a tight hold of their lucky kitten. The ship had the good fortune to survive both world wars.

(Author's collection)

~~~~~~~~~~~~~~~~~~~~~~~~~~~~~~~~~~~~~~~~~~~~~~~~~~~

*E*ven worse than seeing a cat trying to abandon a ship as it prepared to set sail was the sight of two cats fighting on the deck. Superstitious sailors thought this was a sign of certain tragedy. To them, scrapping cats meant the fate of the entire crew had been sealed, and that the devil and an angel had already begun the fight for their souls.

~~~~~~~~~~~~~~~~~~~~~~~~~~~~~~~~~~~~~~~~~~~~~~~~~~~

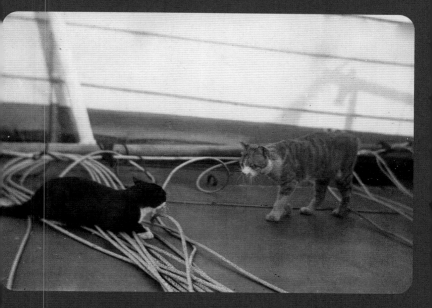

Are these cats on HMS *Cornwall* actually the devil and an angel battling for the souls of the crew? HMS *Cornwall* was sunk by Japanese dive-bombers in 1942.

(J&C McCutcheon Collection)

# Protection against Spirits

~~~~~~~~~~~~~~~~~~~~~

*J*apanese sailors feared that the spirits of the deep would keep their souls for eternity if they were lost at sea. A ship's cat would help defend sailors from the grasping hands of the spirits, which took the form of cresting waves. Calicoes (*mike-neko,* or three-color cat) were the most valued because they were considered the luckiest of the felines and could ward off the ghosts of the drowned. But the sailors had to keep an eye on their towels—Japanese superstition also maintains that certain mischievous cats wrap stolen towels around their heads and dance while loudly singing, "We are cats!" at inopportune times.

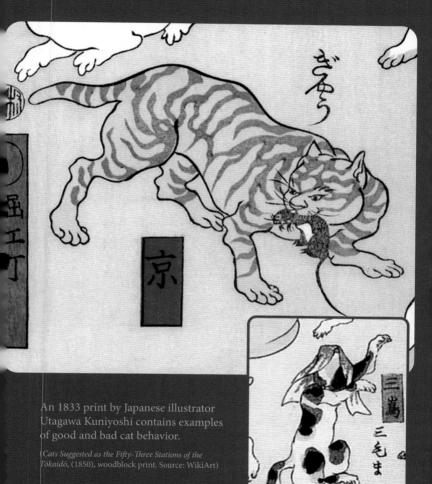

ぎゅう

京

三嶌

三毛ま

An 1833 print by Japanese illustrator
Utagawa Kuniyoshi contains examples
of good and bad cat behavior.

*Cats Suggested as the Fifty-Three Stations of the
Tōkaidō*, (1850), woodblock print. Source: WikiArt)

Attracting Dates

~~~~~~~~~~

The first thing sailors of all nations did when on liberty in a foreign port was look for dates. Sailors accompanied by the ship's cat could greatly increase their odds of attracting the attention of local ladies. If the sailors took the extra step of dressing the cat in a tiny uniform modeled after their own, not even language barriers could discourage women from approaching them.

Getting ready for a big night out with his shipmates? The mascot of HMS *Achilles* wears his uniform while resting in a miniature hammock, circa 1939.

(Author's collection)

# Recruiting Tools

Many aging cats that had lost the speed and agility required to be effective rat catchers were allowed to retire to the relaxed environment of Navy recruiting stations. Much as they had been used as kittens to attract potential dates in foreign ports, they spent their sunset years as bait to lure young men to enlist. A favorite technique of recruiters was to plop the cat down outside the door of the station in hopes that men would stop to pet it, giving the recruiter time to promote the benefits of serving in the Navy.

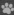

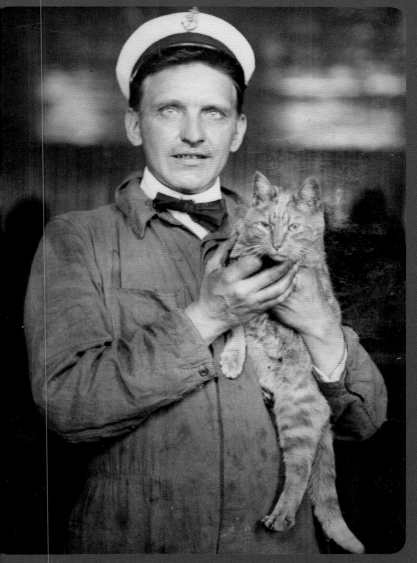

A chief boatswain's mate holds Skeddadle, mascot of the Navy recruiting office in Boston in 1920. Skeddadle was fourteen years old, but the recruiters claimed that he still had the pep of a kitten.

(Author's collection)

# *Gifts and Trade*

*W*estern adventurers witnessed the universal appeal of cats as they began making contact with the indigenous peoples of the Americas and Pacific islands. When encountering the native people of the area now encompassing Panama, the seventeenth-century Welsh buccaneer Lionel Wafer noted that they ignored all offers of gifts because they were fixated on the ship's cat. After the cat had been presented to them, they immediately "paddled off with abundance of joy."[5] The people of Tonga kept trying to take the mascots from Captain James Cook's expedition, prompting one of Cook's officers to write in 1777 that the cats "can be but ill spared from Ships so overrun with rats as ours."[6] American artist and explorer Titian Peale recorded in the 1850s that the Samoan people had developed a passion for cats, "and they were obtained by all possible means from the whale ships visiting the islands."[7]

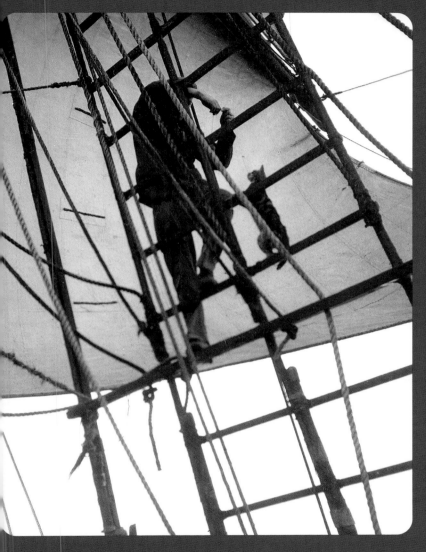

A cat climbs the shrouds of the barque *Pommern*, just as other cats had done for centuries on the ships that introduced them to new cultures all over the globe.

(National Maritime Museum)

# Communications

~~~~~~~~~

Cats were often credited as the source of gossip among the crew. Just as civilians might say they heard a rumor from a little birdie, sailors claimed that they learned the latest scuttlebutt from the ship's cat. There actually is a bit of truth to this: sailors would pass information and jokes to each other by tucking notes into the collar of the cat as it made its rounds from deck to deck. Cats, of course, could always maintain deniability.

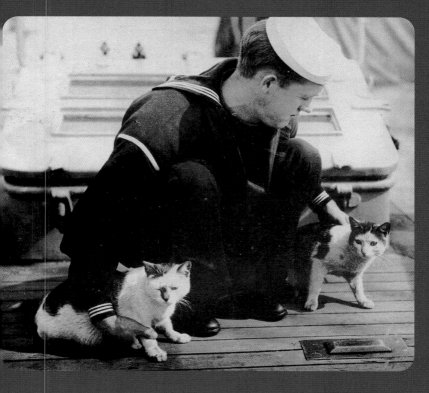

What scuttlebutt is this sailor on the USS *Connecticut* (BB 18)
learning from the ship's cats in 1911?

(J&C McCutcheon Collection)

Colonists

~~~

As European explorers visited new lands on their voyages of discovery, they inadvertently brought an invading force of rats and mice that subsequently launched assaults on islands all over the globe. To combat the scourge they had created, sailors left colonies of cats on the islands. Unfortunately, when cats either eliminated invasive species or learned to coexist with them, they themselves became pests by preying on native populations of birds and other small animals. The sailors could not have predicted that these cat colonies would have an adverse impact on the local ecosystems for generations.

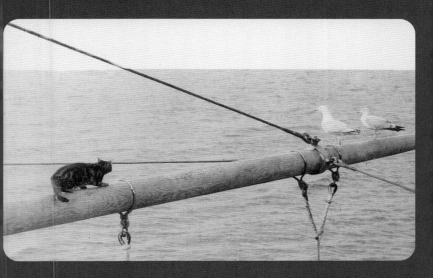

The entire ship was a cat's hunting ground, and rodents were not the only prey.

(J&C McCutcheon Collection)

# Preventive Maintenance

Almost all captains insist that their ships be spotless. For sailors tasked with keeping the decks clean, seagulls are a menace. A flock of them can quickly make the top deck look like the bottom of a pigeon coop. Cats helped reduce the work of the sailors by keeping many winged vandals at bay. A few fearless cats that underestimated the strength of seagulls were carried away after latching on to the leg of one. After a short flight, the cats fell into the water and were recovered by the crew.

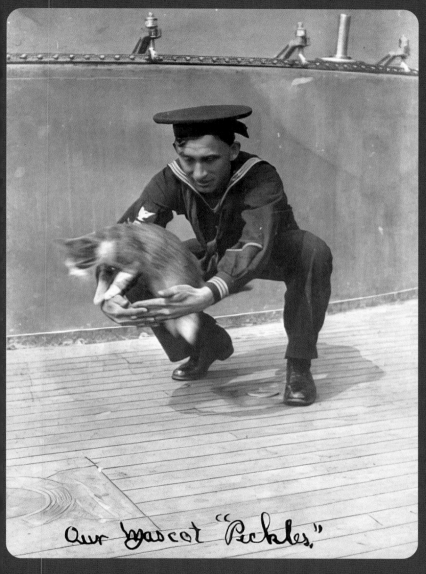

Our mascot "Pickles."

With a clean deck and no pesky seagulls in sight, a sailor has time to play with Pickles the mascot, circa 1900.

(U.S. Naval Institute photo archive)

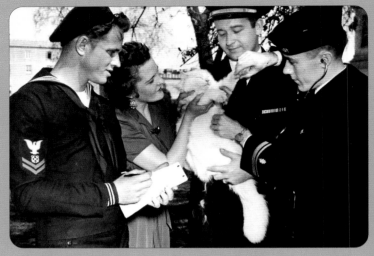

A fluffy Persian cat named Baby receives a physical exam to determine if she qualifies to be a ship mascot, 1943.

(National Archives)

## Gas Detectors

*D*uring World War I, a reporter noted, "There is one thing a cat hates more than she hates dogs and that is—gas."[8] Many cats exhibit an extreme reaction to unpleasant odors by opening their eyes wide, sticking out their tongues, and recoiling in disgust. With the advent of chemical weapons, sailors believed cats would provide visual warnings of approaching gas attacks at sea. The crews of ships transporting chemical weapons thought that a grimacing cat would alert them to any leaking canisters in the hold. Cats were also used—like the proverbial canary in the coal mine—on early submarines to monitor the quality of air.

# PART III

# Claws
# of Fame

# Oscar/Unsinkable Sam

*P*erhaps the most famous trophy cat was a black-and-white that originally had been the mascot on the *Bismarck*. After the feared Nazi battleship was sunk by the Royal Navy, the cat was scooped out of the water by the crew of the destroyer HMS *Cossack*, who named him Oscar. Just a few months later, Oscar would again need to be rescued after the *Cossack* was torpedoed by a U-boat. He was transferred to the aircraft carrier HMS *Ark Royal* and given a new name—Unsinkable Sam. The optimistic name seems to have doomed the *Ark Royal*, because the ship also fell victim to a U-boat. After surviving three sinkings, Oscar/Unsinkable Sam was sent to live out his days in a retired seaman's home in Belfast. While a charming story, several historians believe it was partially or fully fabricated for the sake of raising public morale.

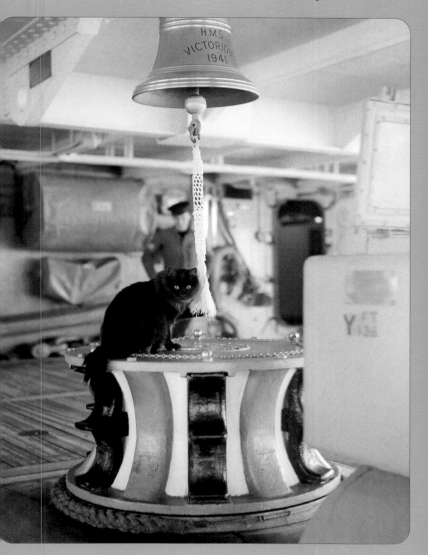

Among the ships that pursued the *Bismarck* in 1941 was HMS
*Victorious. Victorious'* mascot, Tiddles, enjoyed sitting on a capstan
and batting the rope of the ship's bell.

(U.S. Naval Institute photo archive)

# *Blackie/Churchill*

~~~~~~~~~~~~~~~~

When Prime Minister Winston Churchill met President Franklin Roosevelt at the Atlantic Conference in 1941, a photographer captured the British statesman pausing to pat Blackie, mascot of HMS *Prince of Wales.* Surprisingly, the endearing moment was met with criticism. The Cats Protection League scolded the prime minister for committing a major faux pas by patting the cat on the head instead of presenting his hand and allowing the cat to indicate his approval to be touched. Regardless, Blackie became a celebrity and was renamed Churchill to commemorate the special encounter. Months later, Churchill the cat was on the *Prince of Wales* when it was sunk by the Japanese. He was rescued and taken to Singapore with other survivors, but there he disappeared, and his fate is unknown.

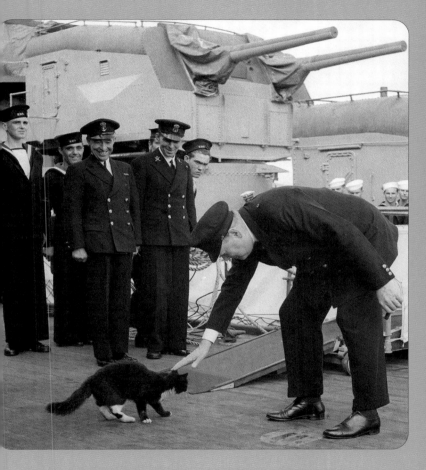

Winston Churchill introduces himself to Blackie of HMS *Prince of Wales*, 1941. Perhaps he was trying to stop Blackie from defecting to the USS *Augusta*, which was tied alongside the British ship. Alcohol was allowed on Royal Navy ships, but the food on U.S. Navy ships was considered to be superior.

(U.S. Naval Institute photo archive)

Simon

~

*W*hen HMS *Amethyst* was attacked by Chinese Communists along the Yangtze River in 1949, Simon, the ship's cat, performed his duties with staunch determination even after being wounded by shrapnel. Simon's dedication raised the morale of the crew and caught the attention of the British public, who saw the cat as symbolic of British perseverance. Simon was the only cat to be awarded the Dickin Medal, given to animals exhibiting gallantry in war. The citation reads, "Be it known that on April 26, 1949, though recovering from wounds, . . . [Simon] did single-handedly and unarmed stalk down and destroy 'Mao Tse Tung,' a rat guilty of raiding food supplies which were critically short."[9]

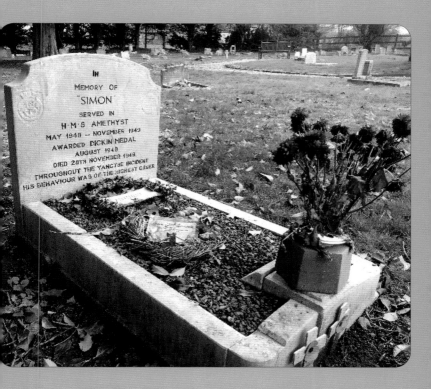

The grave of Simon of HMS *Amethyst* at the Ilford Animal Cemetery in London. The cemetery includes twelve other recipients of the Dickin Medal for bravery.

(Author's collection)

Charlie

D escribed as having monstrous jowls and a taste for grog, Charlie endeared himself to the crew of the USS *Nipsic* when he got the better of a Royal Navy ship's pompous cat during a scrap in Gibraltar sometime in the 1880s. He solidified his fierce reputation when a local vendor, trying to sell monkeys on the ship, saw his entire stock of primates scramble up into the rigging after Charlie decided they were not welcome on the deck. When the ship set sail, the monkeys were still too frightened to come down when they saw Charlie glowering at them from below.

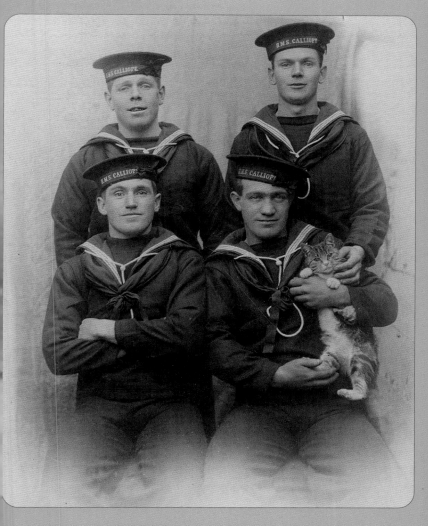

Was the cat of HMS *Calliope* a better good luck charm than Charlie?
It would seem so. When a cyclone hit Samoa in 1889, the USS *Nipsic*
and five other warships were wrecked while HMS *Calliope* managed
to escape any damage.

(J&C McCutcheon Collection)

Dirty Face, Clean Face, Leatherneck, Long Ears, Baltimore City, and Flop

~~~

he cats of the USS *Mississippi* gained international fame after they were trained to climb ladders into tiny hammocks, use their paws to knock over rows of pins in succession, and even perform a bit of music by ringing bells. The sextet was used to entertain ship's visitors during port calls. Their trainer, the ship's chief musician, claimed that he was able to speak both "seagoing English and cat."[10]

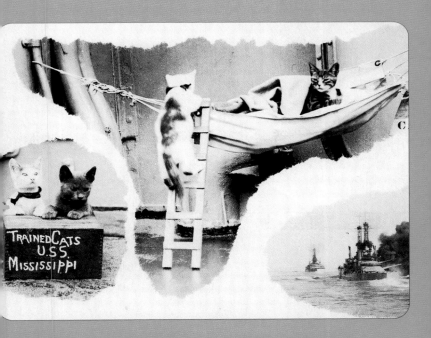

A couple of the famous trained cats of the USS *Mississippi* are ready to greet visitors, while others climb into their little bunks, 1920.

(U.S. Naval Institute photo archive)

# Miss Hap

In 1953 Marine combat correspondent Sergeant Frank Praytor adopted a kitten whose mother had been killed in Korea. Praytor decided to name the kitten Miss Hap "because she was born at the wrong place at the wrong time."[11] Praytor briefly became a celebrity when a photo of him feeding the two-week-old kitten with a medicine dropper was syndicated to 1,700 newspapers. Not only did his newfound fame prompt marriage proposals from around the world, but it also spared him from a court-martial he had been facing for entering one of his combat photos in a magazine contest without obtaining approval from military censors. Because Praytor's act of humanity had attracted the adoration of the public, the Marine Corps decided not to charge him. "That little kitten saved me from the brig,"[12] Praytor would later say.

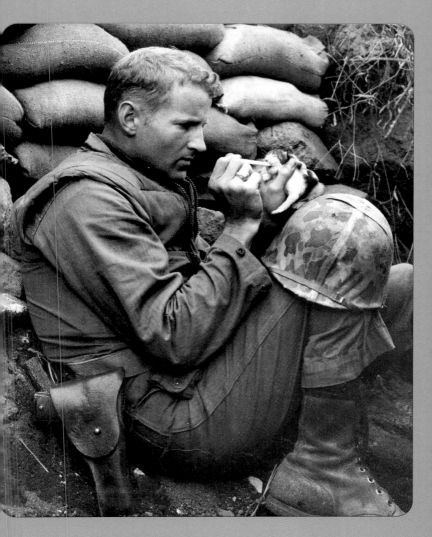

Sergeant Frank Praytor gained a slew of admirers after this photo of him nursing the kitten Miss Hap in Korea was published in thousands of newspapers, 1953.

(Archives Branch, Marine Corps History Division)

# *Nansen*

~~~

*N*ansen was the mascot of the Belgian Antarctic Expedition on board the barque-rigged steamship RV *Belgica*. Beloved by the crew for maintaining their morale in the harsh conditions of the polar region, Nansen boarded the *Belgica* in 1887 with a Norwegian cabin boy who named the kitten after his national hero, explorer Fridtjof Nansen. Nansen the mascot initially seemed quite happy entertaining the crew and receiving their affection, but the twenty-four-hour darkness and extreme cold soon sapped the cat's energy and spirit, and Nansen gained the unfortunate distinction of being the first cat to die in the Antarctic. A crew member lamented the loss of their mascot, writing that he presumed Nansen had departed for "more congenial regions."[13]

Nansen the mascot drawn by Koren, a cabin boy.

(Frederick Cook, *Through the First Antarctic Night, 1898–1899*, London: Heinemann, 1900)

Tom Whiskers

When the mascot of the hospital ship USS *Solace* disappeared in 1919, the commanding officer suspected that the crew of the USS *Bell* had abducted him in port. The commander sent a message to the captain of the *Bell* inquiring about the missing cat, which when last seen was in "dress uniform consisting of a leather collar with brass tag marked USS *Solace*."[14] The captain of the *Bell* responded that Tom Whiskers was indeed on board, but had not been a victim of abduction; rather, he had simply sneaked onto the ship. The captain added that the black cat had lost his collar and was now battleship gray because he had been kept in a paint locker. The *Bell* skipper did not feel he owed anything for the loss of a ten-cent collar because the cat had cost him two dollars in paint.

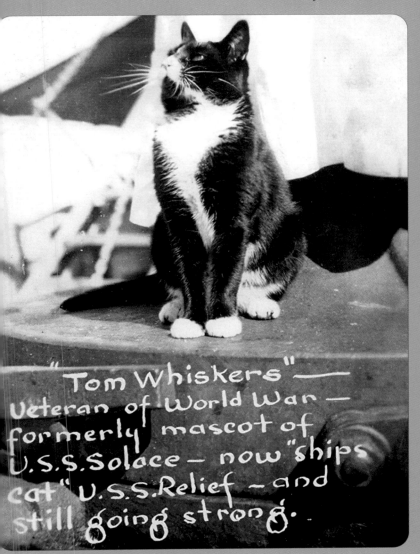

"Tom Whiskers" — Veteran of World War — formerly mascot of U.S.S. Solace — now "ships cat" U.S.S. Relief — and still going strong.

After allegedly being "kitty-napped," Tom Whiskers was returned to the USS *Solace* but then transferred to the new hospital ship USS *Relief* when the *Solace* was decommissioned.

(Author's collection)

Snowball

A black cat ironically named Snowball was a pioneering ship's mascot that made the move from sea to air. When the U.S. Navy purchased the surplus rigid airship *R-38* from Great Britain and redesignated her the *ZR-2*, the American crew brought Snowball for good luck on test flights. Disastrously, the structure of the airship proved to be flawed, and it collapsed during maneuvering trials. The *ZR-2* crashed near Hull, England, in 1921, claiming the lives of forty-four men, including sixteen Americans who constituted almost all of the U.S. Navy's experienced airship personnel. Among the victims was Snowball.

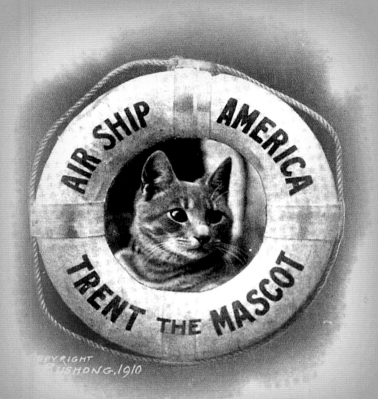

Another pioneering feline aviator was Kiddo of the airship *America*. Kiddo was supposed to bring good luck on an attempt to cross the Atlantic in 1910, but instead became overly excited, prompting the engineer to make one of the first air-to-ground radio transmissions: "Roy, come and get this goddamn cat!" The crew later had to abandon the *America* and take to a lifeboat when the airship struggled to stay aloft. Kiddo was renamed Trent in honor of the ship that rescued the crew.

(Author's collection)

Tom

~~

It was said that almost all sailors had already met Tom in some foreign port before this Senior Cat of the Navy gained national renown. The thirteen-year-old mascot became a press darling after surviving the explosion that destroyed the USS *Maine* in Havana Harbor in 1898. Tom had been feared lost in the disaster, but the *Maine*'s executive officer found the tabby the next day in an area of the ship that had remained above water. Suffering a wounded foot and a bit of singed fur, Tom was transferred to the USS *Fern*, where he resumed his duties as a rat catcher. His story of survival soon appeared in newspapers across the country.

The mascot (bottom center) with mess cooks on the USS *Maine* is possibly Senior Cat of the Navy Tom, 1896. The *Maine* had two other cats that did not survive the 1898 explosion.

(U.S. Naval Institute photo archive)

Trim

The career of Trim was so illustrious that he has been memorialized with at least three statues. In the early nineteenth century, Trim lived the life of an intrepid adventurer while accompanying English cartographer and navigator Captain Matthew Flinders. The black cat with feet "dipped in snow" and a "white star on his breast" served with Flinders on several Royal Navy ships, during which time he circumnavigated Australia, survived a shipwreck, and was taken as a prisoner of war by the French. Flinders later wrote Trim's epitaph, saying Trim had been "the most affectionate of friends, faithful of servants, and best of creatures."[15]

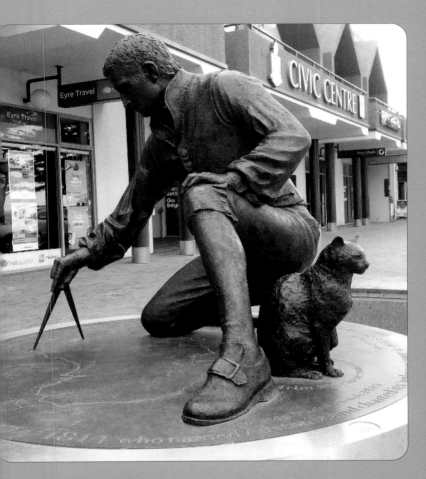

Statue of Matthew Flinders with his loyal cat, Trim, in Port Lincoln, South Australia. Statues of Flinders and Trim can also be found in Donington, England, and Sydney, Australia.

(Camloo)

Bounce

~~~~~~~~

M any cat lovers insist that most cats are too proud to be trained to perform simple tricks for the entertainment of people. However, Bounce of the USS *Chicago* apparently placed more value on pride of country than his own feline ego. He gained global fame because whenever "The Star-Spangled Banner" was performed, he stood on his hind legs and gave a salute with his tiny paw.

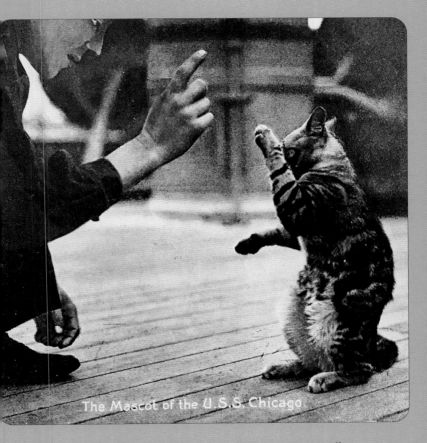

The Mascot of the U.S.S. Chicago

Bounce of the USS *Chicago* gives a salute, 1905. Bounce was still on the *Chicago* when the ship played a key role in the evacuation of San Francisco following the devastating earthquake of 1906.

(Author's collection)

# Suribachi Sue

During the Battle of Iwo Jima in 1945, Corporal Edward Burckhardt of the 5th Marine Division found a kitten that likely had been a mascot of Japanese troops. He jokingly claimed that the kitten had captured him, and named her Suribachi Sue after the mountain that dominated the island. Because he was part of the battle, Burckhardt gave the cat to another Marine assigned to headquarters. Suribachi Sue survived the brutal battle but sadly died on the ship back to the United States after the war.

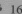

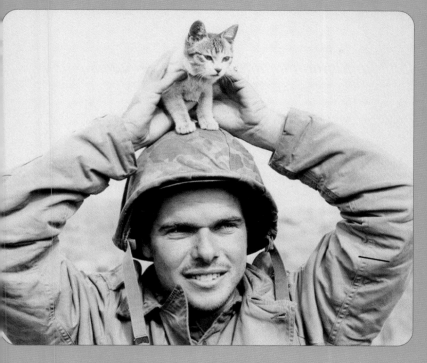

Marine corporal Edward Burkhardt with Suribachi Sue, 1945. Joe Rosenthal took a different photo of Burckhardt with Sue that appeared in newspapers throughout the United States. Rosenthal's photo of the flag-raising on Mount Suribachi would become one of the most iconic images of the war.

(NARA)

# *Pooli*

〜

**B**orn in Pearl Harbor on the Fourth of July, Princess Papule was destined to be an American hero. Called Pooli for short, she served on the attack transport USS *Fremont* during several of the fiercest battles in the Pacific, including the Marianas, Leyte, Palau, and Iwo Jima. She took her position in the ship's mailroom every time she heard the call to battle stations, and she emerged from each conflict unscathed, earning three service ribbons and four battle stars. She also joined other shellbacks by becoming a Daughter of Neptune after crossing the equator. Quite the distinguished career for any sailor.

By 1959 Pooli was able to do something that not many other World War II veterans could accomplish—still fit in her uniform more than a decade after retiring.

(*Los Angeles Times* Photographs Collection, UCLA Library)

## Fred Wunpound

Fred Wunpound, the mascot of HMS *Hecate*, got his name because he weighed one pound and cost £1 when he was purchased from the Royal Society for the Prevention of Cruelty to Animals. Able Seacat Fred Wunpound had logged 250,000 miles on the ship before the strict 1974 quarantine laws ended his naval career. He retired as a Leading Seacat with two good conduct medals, but also one disgraceful conduct medal for an unfortunate fish-market incident. When he passed away at the age of ten, British newspapers published his obituary.

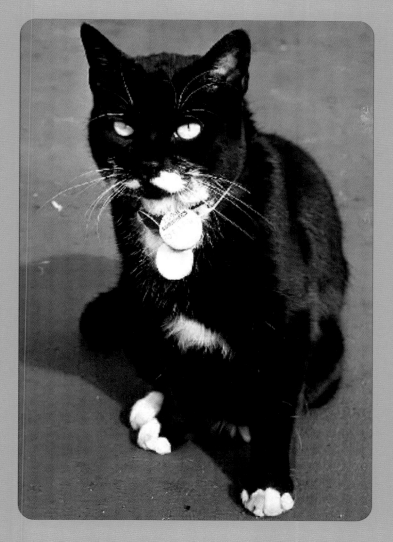

The well-traveled Fred Wunpound of HMS *Hecate*. Fred's shipmates slyly submitted a census form on his behalf, which was accepted and then counted toward the total population of Scotland.

(Courtesy of Navy News)

# Thomas C. Crusher

In 1974, when cats were prohibited from deploying on Royal Navy ships, many mousers continued to serve after transferring to shore duty. Thomas C. Crusher prowled the Royal Navy Patrol headquarters in Devonport to control the rodent menace. Crusher was so effective that he was awarded two GCBs (Good Cat Badges) between 1985 and 1992.

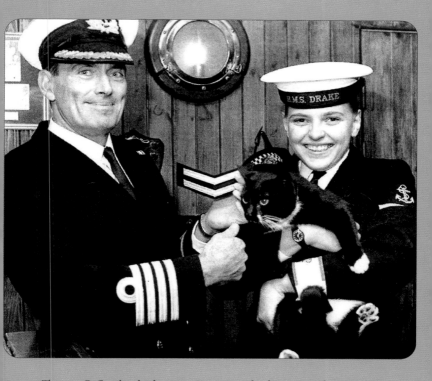

Thomas C. Crusher looks more eager to get back to mouse hunting than to receive his award from the captain of HMS *Drake*. The sizable cat appears to be either a very lethal hunter or the recipient of many treats.

(Courtesy of Navy News)

## The Miller House Cat

~~~~~~

Situated on Embassy Row in Washington, D.C., is a striking Northern Renaissance–style house built in 1901 for Frederick Augustus Miller. Miller had served as a Union Navy officer during the U.S. Civil War, so the house was designed in a nautical style. Included among the maritime figures occupying various parts of the house is a statue of a ship's cat that still watches over Massachusetts Avenue to this day.

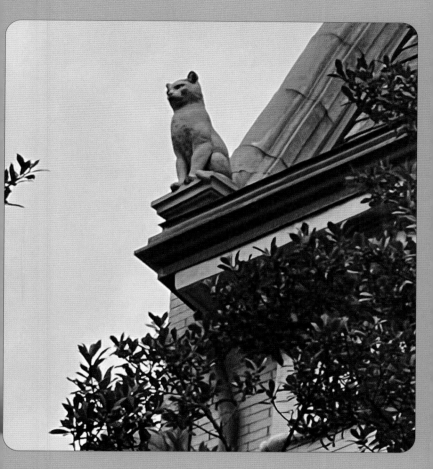

Commander Frederick Augustus Miller's cat has been watching over his house in Washington, D.C., for more than a century.

(Author's collection)

Tom the Terror

*B*orn at the Brooklyn Navy Yard with littermates that all went on to serve as ship cats, Tom had already earned the reputation of being a fierce battler before joining the USS *Terror* as a member of the ship's company. Tom was a veteran of several engagements during the Spanish-American War and was adored by the crew despite his tendency to scratch and bite when feeling testy. Tom eventually transferred to the USS *Annapolis,* where the midshipmen learned to appreciate his supreme ratting skills.

A newspaper illustration of the feared and respected Tom the Terror that accompanied an 1899 syndicated article about the cantankerous cat's exploits.

(*Republican News Journal*, Newkirk, Oklahoma Territory)

Kicia

~

*T*he commanding officer of the ORP *Burza* was
pleased when Kicia wandered onto the Polish
Navy destroyer. As an experienced seaman, he knew
it was a good omen that Kicia had selected his ship.
Shortly after the outbreak of World War II, Kicia birthed
six kittens in a cabin in the stern. The crew was puzzled
when Kicia decided to move her kittens to a cabin in
the bow, even though she had to travel over a slick,
storm-soaked deck. Days later, the *Burza* was attacked by
German dive-bombers that destroyed the cabin in which
the litter had been born. By chance or intuition, Kicia's
action had saved her kittens.

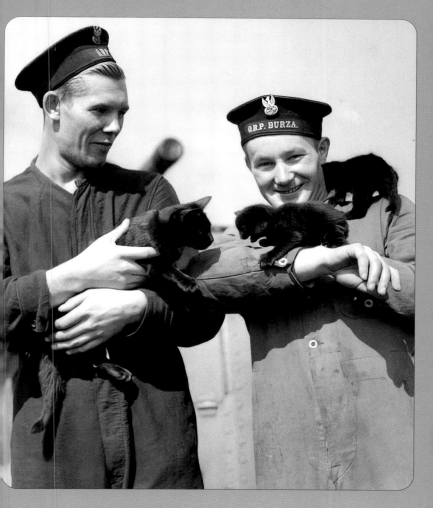

Polish sailors from the ORP *Burza* play with Kicia and two of her six kittens, which she moved to safety before an attack.

(U.S. Naval Institute photo archive)

Mrs. Chippy

When carpenter Harry "Chippy" McNish joined Sir Ernest Shackleton's British Imperial Trans-Antarctic Expedition to serve as the master shipwright on the *Endurance* in 1914, he brought along a tabby cat that became the ship's mascot. Despite being male, he was known as Mrs. Chippy because he followed McNish throughout the ship like a doting wife. McNish passed away in 1930 and was buried in Wellington, New Zealand. Because they had been inseparable in life, a life-size bronze statue of Mrs. Chippy was added to McNish's grave in 2004.

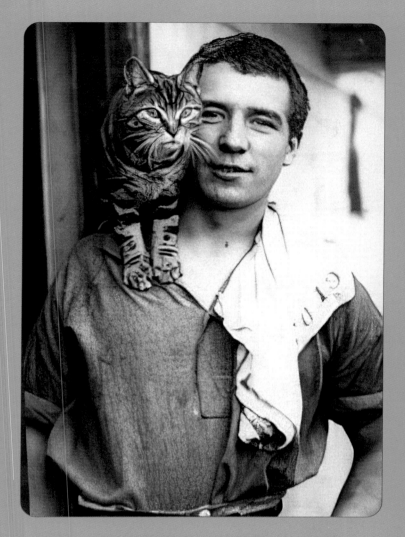

Mrs. Chippy sits on the shoulder of Perce Blackborow, who was a stowaway on the *Endurance*. When Blackborow was discovered hiding on the ship, Shackleton warned him that stowaways would be the first to be eaten when food supplies ran low.

(Scott Polar Research Institute)

Tom K. Fathoms

The crew of the USS *Maury* was clearly more attached to Tom K. Fathoms than he was to them. Tom took unauthorized leave whenever he saw the opportunity, jumping ship in Norfolk, Halifax, and San Juan. He once managed to evade the shore patrol for three weeks in Puerto Rico before being caught. He was placed on a ship that delivered him to the Brooklyn Navy Yard, where he was transferred back to the *Maury* to continue his mouse-catching duties.

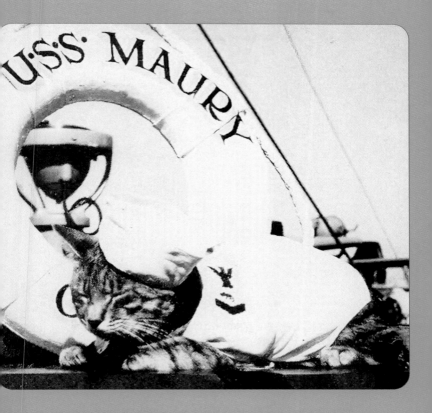

Tom K. Fathoms of the USS *Maury* wears the rating insignia of
Mousecatcher Third Class. Because of his repeated willful dereliction
of duty and tendency to take unauthorized leave, he probably never
earned a promotion.

(U.S. Navy)

Notes

1. Department of the Navy, *OPNAV Instructions* (OPNAVINST), 3120.32D sec. 5.1.42, 16 July 2012, https://www.secnav.navy.mil/doni/ Directives/03000%20Naval%20Operations%20and%20Readiness/03-100%20 Naval%20Operations%20Support/3120.32D%20W%20CH-1.pdf.

2. Elizabeth Banks, *On the Boat That Uncle Sam Built* (Cambridge, MA: Harvard University Press, 1917), 5.

3. E. Callaway, "How cats conquered the world (and a few Viking ships)," *Nature* (2016). https://doi.org/10.1038/nature.2016.20643.

4. Adam Anderson, *An Historical and Chronological Deduction of the Origin of Commerce, from the Earliest Accounts,* vol. 3 (London: J. Walter Printing House, 1787), 60.

5. Lionel Wafer, "Wafer's Darien," reprinted from original edition (London, James Knapton, 1699) in *A New Voyage and Description of the Isthmus of America,* edited by George Parker Winship (Cleveland, OH: Burrows Brothers, 1903), 114.

6. J. C. Beaglehole, ed., *The Journals of Captain James Cook on His Voyages of Discovery,* vol. 3 (New York, NY: Cambridge University Press, 1967), 133.

7. Titian Ramsay Peale, *Mammalia and Ornithology: US Exploring Expedition 1838–1842* (Philadelphia: C. Sherman, 1848), 211.

8. *The Literary Digest,* vol. 63 (Oct.–Dec. 1919), 29.

9. Dickin Medal citation quoted in Patrick Roberts, "Purr 'n' Fur," *Famous Felines* (n.d.), http://www.purr-n-fur.org.uk/famous/simon.html.

10. *Boston Globe,* 4 January 1920, 48.

11. *Detroit Free Press,* 26 October 1952, 9.

12. Chas Henry and U.S. Naval Institute Staff, "Korean War Marine Made Famous in Kitten Photo Dies," *USNI News,* 25 January 2018.

13. Frederick A. Cook, *Through the First Antarctic Night* (London: William Heinemann, 1900), 326 (entry for June 26).

14. *Grog Ration* 3, no. 2 (March–April 2008): 6.

15. "Matthew Flinders' Biographical Tribute to His Cat Trim 1809," *The Flinders Papers: Letters and Documents about the Explorer Matthew Flinders (1774–1814),* https://flinders.rmg.co.uk/DisplayDocumentf71b .html?ID=92&CurrentPage=1&CurrentXMLPage=8

About the Author

SCOT CHRISTENSON is the director of communications for the U.S. Naval Institute. He began his career as a television producer and journalist before going on to develop and manage media strategies for a wide range of organizations, including amusement parks, zoos, think-tanks, and lobbying firms. He has written about history and pop culture for several periodicals and frequently serves as a consultant on television and film productions. He lives in Alexandria, Virginia, with his wife.

The **Naval Institute Press** is the book-publishing arm of the U.S. Naval Institute, a private, nonprofit, membership society for sea service professionals and others who share an interest in naval and maritime affairs. Established in 1873 at the U.S. Naval Academy in Annapolis, Maryland, where its offices remain today, the Naval Institute has members worldwide.

Members of the Naval Institute support the education programs of the society and receive the influential monthly magazine *Proceedings* or the colorful bimonthly magazine *Naval History* and discounts on fine nautical prints and on ship and aircraft photos. They also have access to the transcripts of the Institute's Oral History Program and get discounted admission to any of the Institute-sponsored seminars offered around the country.

The Naval Institute's book-publishing program, begun in 1898 with basic guides to naval practices, has broadened its scope to include books of more general interest. Now the Naval Institute Press publishes about seventy titles each year, ranging from how-to books on boating and navigation to battle histories, biographies, ship and aircraft guides, and novels. Institute members receive significant discounts on the Press' more than eight hundred books in print.

Full-time students are eligible for special half-price membership rates. Life memberships are also available.

For more information about Naval Institute Press books that are currently available, visit www.usni.org/press/books. To learn about joining the U.S. Naval Institute, please write to:

Member Services
U.S. Naval Institute
291 Wood Road
Annapolis, MD 21402-5034
Telephone: (800) 233-8764
Fax: (410) 571-1703
Web address: www.usni.org